DIGITAL PHOTOGRAPHER'S GUIDE TO **DRAMATIC**

PHOTOSHOP EFFECTS

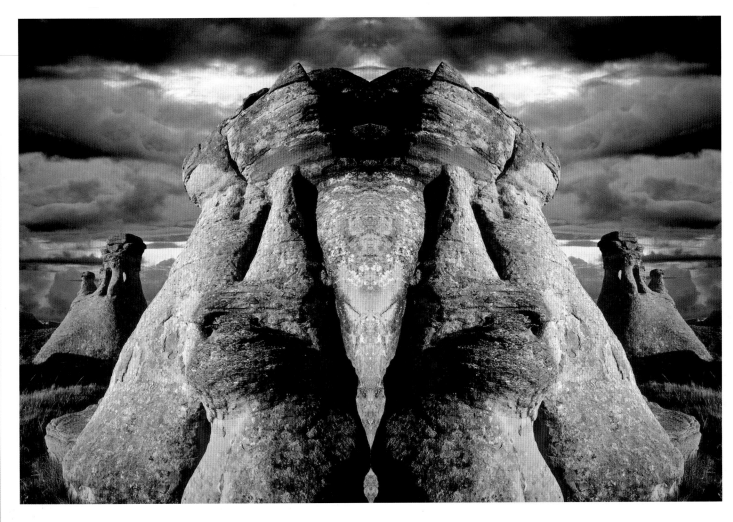

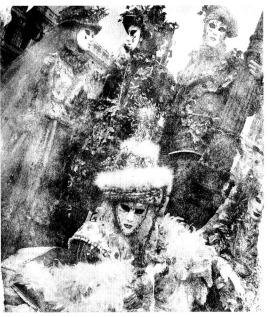

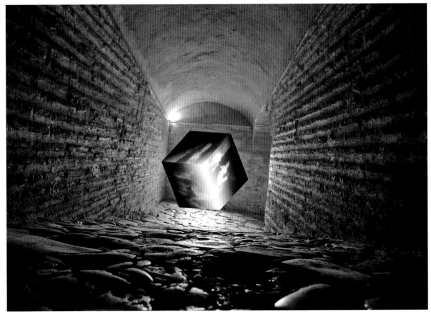

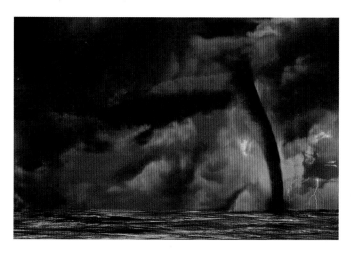
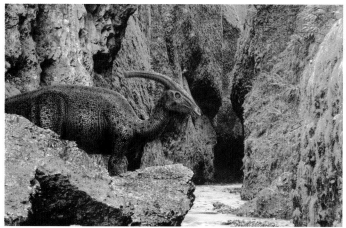

DIGITAL PHOTOGRAPHER'S GUIDE TO **DRAMATIC**

PHOTOSHOP EFFECTS

pixiq

An Imprint of Sterling Publishing Co., Inc.
New York

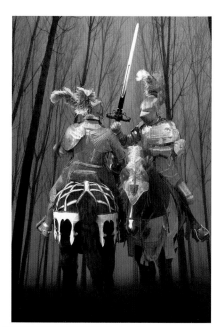
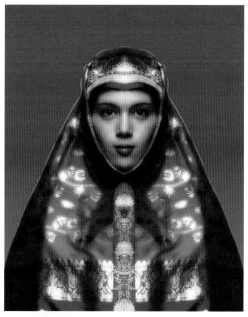

Editor: Rebecca Shipkosky
Interior Design: Sandy Knight, Hoopskirt Studio
Cover Design: Sandy Knight, Hoopskirt Studio

Library of Congress Cataloging-in-Publication Data

Zuckerman, Jim.
 Digital photographer's guide to dramatic Photoshop effects / Jim Zuckerman. – 1st ed.
 p. cm.
 Includes index.
 Summary: "A "cookbook" for creating dramatic and sometimes surreal effects using Adobe Photoshop, including methods to create entirely new composite images or
 simply improve existing images"– Provided by publisher.
 ISBN 978-1-4547-0118-7 (pbk.)
 1. Photography–Special effects. 2. Photography–Digital techniques. 3. Adobe Photoshop. I. Title.
 TR148.Z79 2012
 770–dc23
 2011044541
10 9 8 7 6 5 4 3 2 1

First Edition

Published by Pixiq
An Imprint of Sterling Publishing Co., Inc.
387 Park Avenue South, New York, N.Y. 10016

Text © 2012 Jim Zuckerman
Photographs © 2012 Jim Zuckerman unless otherwise specified

Distributed in Canada by Sterling Publishing,
c/o Canadian Manda Group, 165 Dufferin Street
Toronto, Ontario, Canada M6K 3H6

If you have questions or comments about this book, please contact:
Pixiq
67 Broadway
Asheville, NC 28801
(828) 253-0467

Manufactured in China

ISBN 13: 978-1-4547-0118-7

For information about custom editions, special sales, premium and corporate purchases, please contact
Sterling Special Sales Department at 800-805-5489 or specialsales@sterlingpub.com. For information about
desk and examination copies available to college and university professors, requests must be submitted to
academic@larkbooks.com. Our complete policy can be found at www.larkcrafts.com.

CONTENTS

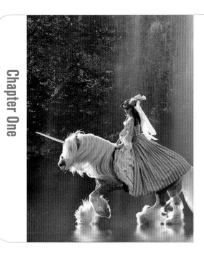

Chapter One

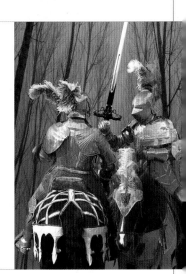

Chapter Two

Chapter Three

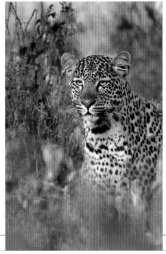

Chapter Four

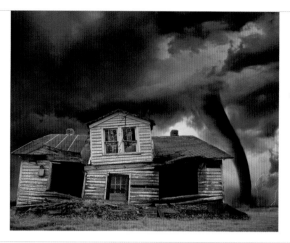

Chapter Five

Chapter Six

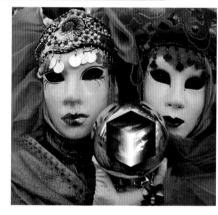

Chapter Eight

Chapter Seven

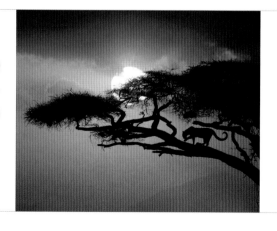

Chapter Nine

Chapter Ten

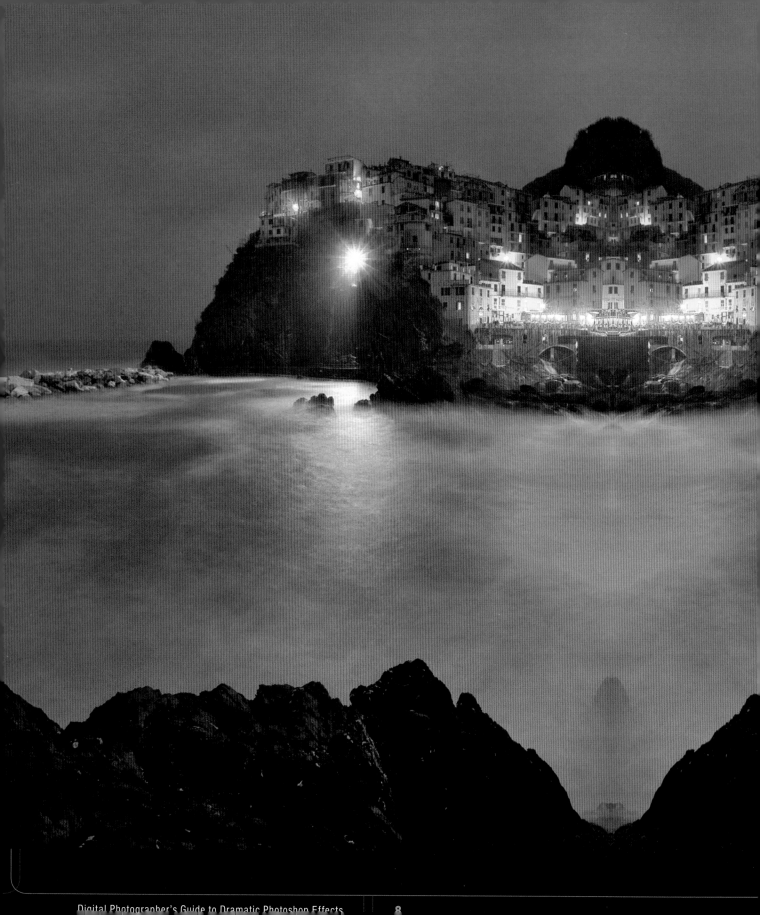

I am passionate about Photoshop because it allows me to be creative with no bounds. Never has there been a tool for photographers that is so powerful, so exciting, and so limitless. This book will expand your thinking as to what can be done with photography today, but trust me when I tell you that this is only the tip of the iceberg. No single text can reveal all of Photoshop's secrets. It is a program with endless possibilities because the ingenuity and creativity of photographers is without end.

What I do in the following pages is present many of my favorite images that I have created in Photoshop, and I explain in step-by-step fashion how I accomplished each one. You can follow along using your own images, and even though your pictures are different than mine, you will learn the concepts and the strategy in putting these images together.

I hope that you will consider this an idea book. When you buy one of those thick, authoritative (and intimidating) books on Photoshop, page after page is filled with explaining what every icon and every drop-down menu does. However, these books are usually devoid of the type of creativity that will inspire you. In this book, I hope to do just that—to get you excited about what Photoshop's tools can do so that you will apply this knowledge to your own work.

There is something else I hope you will take away from this book: Seeing the images I put together should encourage you to focus on a variety of photographic subjects that you might not have pursued in the past. You will learn to think in terms of components that will be composited with other elements in the future, and this opens up entirely new possibilities in picture making.

It's a great time to be a photographer, and one of the reasons for that is that Photoshop has completely transformed our ability to express ourselves with a camera. On the following pages, you will find a map of the Photoshop workspace and some shortcuts that I hope will help you as you begin your journey. Furthermore, some projects in this volume will be more advanced than others, and each chapter's opening page will tell you whether the project is beginner, intermediate, advanced, or expert.

INTRODUCTION

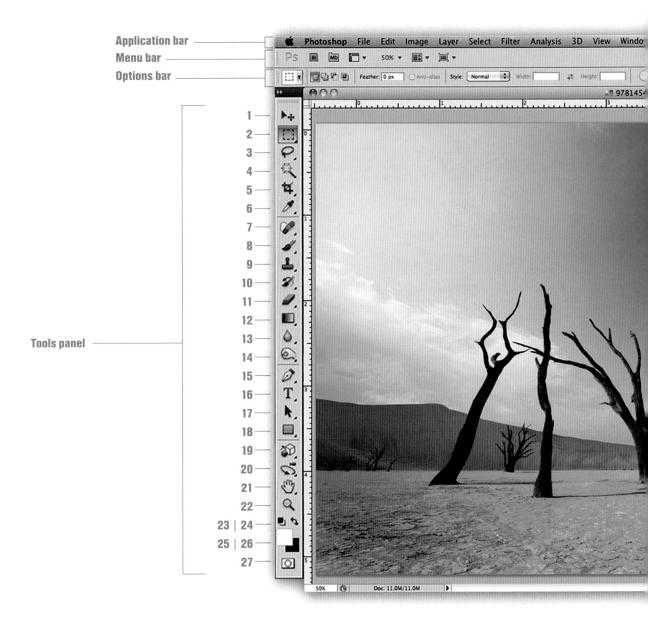

Application bar

Menu bar

Options bar

Tools panel

1 **Move tool**

2 **Rectangular Marquee tool** | Elliptical Marquee tool | Single Row Marquee tool | Single Column Marquee tool

3 **Lasso tool** | Polygonal Lasso tool | Magnetic Lasso tool

4 **Quick Selection tool** | Magic Wand tool

5 **Crop tool** | Slice tool | Slice Select tool

6 **Eyedropper tool** | Color Sample tool | Ruler tool | Note tool | Count tool*

7 **Spot Healing Brush tool** | Healing Brush tool | Patch tool | Red Eye tool

8 **Brush tool** | Pencil tool | Color Replacement tool | Mixer Brush tool

9 **Clone Stamp tool** | Pattern Stamp tool

10 **History Brush tool** | Art History Brush tool

11 **Eraser tool** | Background Eraser tool | Magic Eraser tool

12 **Gradient tool** | Paint Bucket tool

13 **Blur tool** | Sharpen tool | Smudge tool

14 **Dodge tool** | Burn tool | Smudge tool

15 **Pen tool** | Freeform Pen tool | Add Anchor Point tool | Delete Anchor Point tool | Convert Point tool

16 **Horizontal Type tool** | Vertical Type tool | Horizontal Type Mask tool | Vertical Type Mask tool

17 **Path Selection tool** | Direct Selection tool

18 **Rectangle tool** | Rounded Rectangle tool | Ellipse tool | Polygon tool | Line tool | Custom Shape tool

19 **3D Object Rotate tool*** | 3D Object Roll tool* | 3D Object Pan tool* | 3D Object Slide tool* | 3D Object Scale tool*

20 **3D Rotate Camera tool*** | 3D Roll Camera tool* | 3D Pan Camera tool* | 3D Walk Camera tool* | 3D Zoom Camera tool*

21 **Hand tool** | Rotate View tool

22 **Zoom tool**

23 **Default Foreground and Background Colors button**

24 **Switch Foreground and Background Colors button**

25 **Foreground Color button**

26 **Background Color button**

27 **Edit in Quick Mask Mode button**

*At the time of writing, these tools are only available in the Expanded version of Photoshop.

Panel Menu buttons

Panels

PHOTOSHOP WORKSPACE

When you work in Photoshop or Elements, you may want to use the shortcut keystrokes that save time and the laborious hand movements required to constantly access the drop-down menu commands. There are many shortcut keystrokes and key combinations, and you'll probably never need to learn all or even most of them. However, there are some shortcuts that should be part of your Photoshop lexicon, simply to make your work easier and more efficient.

Here is a list of the shortcuts I use all the time. The Ctrl/Command prefix means that if you use a PC computer, you will use the Ctrl key along with the letter key, while if you work on an Apple machine, you'll use the Command key plus the letter key. The way the shortcuts work is as follows: First you press the Command or the Ctrl key and then you hit the letter key so both are depressed at the same time.

If a command has a shortcut, you will see it indicated to the right side of every drop-down menu command. In **figure A**, I've circled in red the shortcut for Select > All, which is Ctrl or Command + A. Other symbols used refer to the Shift key and the Option or Alt key.

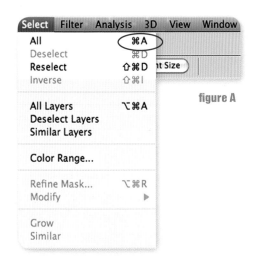

figure A

Shortcuts for Commands

Ctrl/Command + A = Selects the entire picture.

Ctrl/Command + C = Copies selection to the clipboard, Photoshop's temporary and invisible holding place for one photo (or portion of a photo) at a time.

Ctrl/Command + V = Pastes the image in the clipboard on top of a photo.

Shift + Ctrl/Command + V = Pastes the image in the clipboard into a selection.

Ctrl/Command + U = Brings up the Hue / Saturation dialog box.

Ctrl/Command + B = Brings up the Color Balance dialog box.

Ctrl/Command + L = Brings up the Levels dialog box.

Ctrl/Command + M = Brings up the Curves dialog box.

Ctrl/Command + S = Saves the image and erases the original.

Ctrl/Command + Z = Undoes the last command.

Option + Command + Z = Multiple Undo on a Mac.

Alt + Ctrl = Multiple Undo on a PC.

Ctrl/Command + W = Closes a window.

Ctrl/Command + Q = Quits any program.

Ctrl/Command + P = Prints a document or image.

Ctrl/Command + H = Toggles back and forth between hiding the marching ants of a selection. When you use this command, the photo or the portion of the photo is still selected, but the annoying marching ants are hidden from view.

Ctrl/Command + J = Makes duplicate layer.

Ctrl/Command + D = Deselects a selection.

Ctrl/Command + I = Inverts the image, i.e., makes it negative where all the light and dark tones and colors are reversed.

Ctrl/Command + F = If you apply a plug-in filter, this command repeats the application of the filter.

Ctrl/Command + T = Opens the Free Transform command, which puts a box around a layer allowing you to resize or rotate it.

Space bar = Press and hold when an image is magnified to get the Hand tool so you can freeform scroll through your image.

Shortcuts for the Tools panel

Press the **V** key only: Selects the **Move tool**. ⎯⎯

Press the **M** key only: Selects the **Marquee tool**. ⎯⎯

Press the **W** key only: Selects the **Magic Wand tool**. ⎯⎯

Press the **C** key only: Selects the **Crop tool**. ⎯⎯

Press the **J** key only: Selects the **Healing Brush**. ⎯⎯

Press the **B** key only: Selects the **Brush tool**. ⎯⎯

Press the **S** key only: Selects the **Clone tool**. ⎯⎯

9781454701187_a0801.JPG @ 50% (RGB/8*)

SHORTCUTS

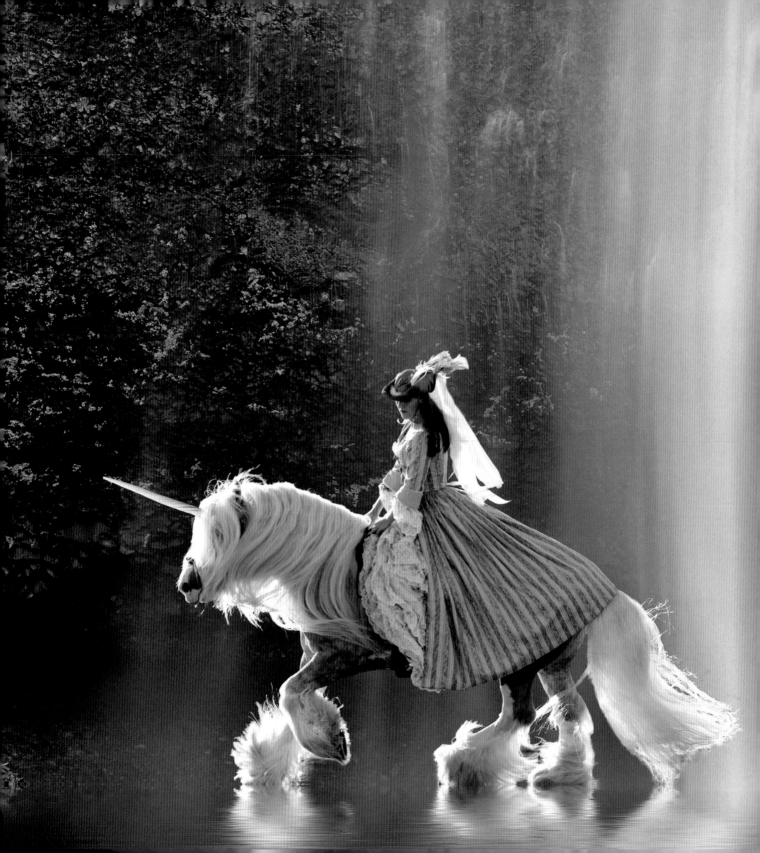

THE LADY AND THE UNICORN

1

One of the most stunning breeds of horses is the Gypsy Vanner. When I first discovered this breed, I was immediately captivated by the horses' unique beauty and grace. Using the Internet, I found a farm near my home that rears these horses, and I arranged to photograph a model in 19th century attire riding a particularly impressive stallion. Unfortunately, the background at this farm was not what I had in mind (**photo 1.1**), so I started thinking about ways to complement the horse and rider. The horse's spectacular feathering (this refers to all the hair on the lower legs and feet) suggested a fantasy environment. I came up with the idea of a unicorn prancing in a magical location, so that's the goal I wanted to achieve.

However, all that hair is problematic. This is one of the biggest challenges for Photoshop, and I rarely attempt to separate a subject from a background if it has a lot of fine hair. It can be done, but it usually does not look 100% perfect. Photographers end up blurring the edges of the hair, and that's not how it looks in reality. In an enlarged print, where the hair meets the new background, the transition just doesn't look believable. The only exception to this is when the original subject was photographed against a

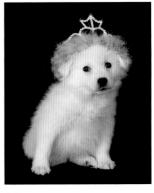

1.2

background where there is significant contrast. For example, I photographed the puppy (**1.2**) against black specifically so I could replace the background. The white against black provides enough contrast for Photoshop to distinguish between the subject and the background. I prefer to use black velvet as the background because this kind of fabric absorbs light better than most material and the background photographs as rich black, usually without recording any of the fabric's texture.

The horse had backlit blonde hair, but the background was not uniformly dark to provide the kind of contrast needed to perfectly separate the feathering. Initially, I thought this would be impossible, but I really wanted this to work. I spent a lot of time thinking about it until I came up with a possible solution. I wasn't sure it would work until I tried it.

1.1

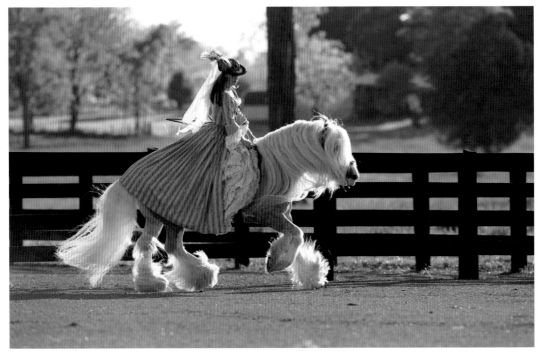

The Pen Tool

There are several tools in Photoshop used to select a subject or an area of a picture. These include the Marquee tool, the Lasso tool, the Magic Wand tool, and the Quick Selection tool. None of these are as accurate as the Pen tool, however. The Pen tool intimidates many people, but it is actually easy to use. It is indeed laborious to make a detailed selection, but once it's finished, you don't have to ever do it again, and it will be perfect.

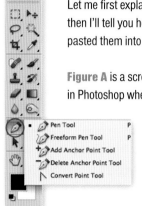

Let me first explain how to use the Pen tool, and then I'll tell you how I cut out the horse and rider and pasted them into a new environment.

Figure A is a screen capture of the Tools panel in Photoshop where I've circled the Pen tool. Your Tools panel may be in single file, but I prefer the two-column arrangement. You can toggle back and forth between single and double columns with the tiny double arrows in the upper right corner of the panel.

figure A

When you click and hold on the Pen tool, you can see an expanded view containing the various options associated with it. Don't let this overwhelm you because, to be honest, you only need to know one of them besides the Pen tool itself—the Delete Anchor Point tool. I'll get to that in a second.

Before you make a selection, two icons need to be selected in the toolbar to make the Pen function properly. **Figure B** illustrates what you see when the Pen tool is selected, and the circles indicate the icons that should be chosen.

The Pen tool is now ready to be used. It simply puts down a series of dots, or anchor points, along the edge of the subject, and when the last point meets the first point, you've created what Photoshop calls a path. I enlarge the photography to 300% in order to apply

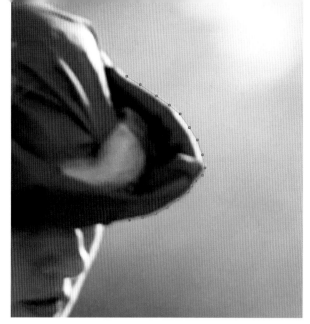

figure C

the anchor points with the Pen tool. One click on the mouse puts one anchor point on the edge of the subject, and you simply lay down as many anchor points as needed to define the shape of the subject. The more points you place, the more accurate the final selection. You can see in **figure C** that I've just begun to select the model, starting at the top of her hat.

Instead of using a mouse with the Pen tool, I use a Wacom tablet (at right). It gives much more control over placing the anchor points. A mouse can be used to place anchor points, but it is awkward and slow. One tap using the tip of the pen on the surface of the tablet equals one click on a mouse. I actually use a Wacom tablet for all my Photoshop work. I recommend getting the 4 x 6-inch size because it takes up less space on your desk, it's less expensive, and it requires fewer hand movements. At first, the tablet will seem uncomfortable to use, but after a couple of hours it will seem like a normal extension of your hand and arm.

figure B

If you make a mistake and place an anchor point incorrectly, it's a simple matter to remove it. Choose the Delete Anchor Point tool, click on the point to be removed, and then again choose the Pen tool. This is important: To resume adding anchor points, you must click on the last anchor point in the sequence, and then you can continue the process of laying down the anchor points along the subject's edge.

When anchor points have been placed around the entire subject and the last point connects with the first point, the path is complete. However, this is not yet a completed selection. To convert the path into a selection, go to the Paths panel and click on the tiny icon in the upper right corner (**figure D**). If the Paths panel is not open, go to Window > Paths. This will allow you to pull down a submenu and choose Make Selection. A new dialog box opens, and you will be asked to choose a Feather Radius. I always choose one pixel. Now click OK, and the path becomes a selection, complete with the familiar marching ants.

At this point, use the drop-down menu command Select > Save Selection. After all the time invested in making a complex selection, you don't want to do it again. This command saves the selection, but to permanently make it a part of the image, you have to use File > Save (or you can make it an entirely new digital file by using File > Save As).

At some point in the future when you want to activate the selection again, use Select > Load Selection.

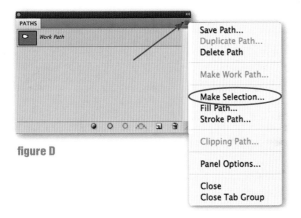

figure D

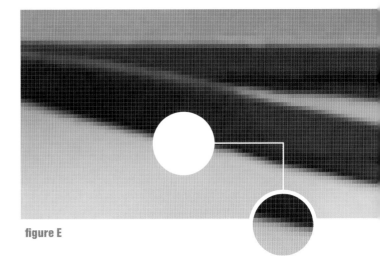

figure E

Transition Zone

If you enlarge a photograph to 300% or more using the Zoom tool, you can see that the image is made up of pixels. The demarcation line between the edge of a subject and the background is not a sharp line. There is what I call a "transition zone" that is made up of three or four pixels. The pixels in this zone consist of several shades of color as you can see in **figure E** (this has been enlarged to 1200%). When you lay the anchor points along the edge of the subject, you have to make the decision where exactly you will place the points in this transition zone.

When the selection is completed, you don't want to include any of the colors in the original background. At the same time, you don't want to lose any of the detail of the subject. You'll have to decide as best you can where to define the edge of the selection, and then after you see what the combination of the subject and the new background looks like, you can do some additional tweaking to make it as close to perfect as possible. More about that in a moment.

Cutting Out the Horse and Rider

I enlarged the image to 600% in order to select the horse exactly. I had never worked at this magnification, but it was important to retain every hair to make the composite as believable—and beautiful—as I could. I used the Pen tool and placed anchor points all around the periphery of the horse. Every hair, every detail, had to be outlined precisely. This took two and a half hours. I had never spent that much time on a selection before.

The biggest problem I faced was that the individual hairs were very thin, and I had to be careful to retain as much of the hair shafts as possible. At the same time, I tried to eliminate as much of the background as I could. The situation was complicated by the fact that some of the hair was backlit,

figure F

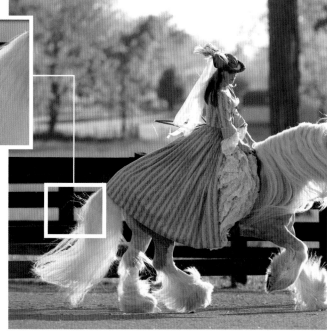

some was in shadow, and the way the sun was absorbed or reflected in the hair wasn't uniform. Look at an enlarged section of the edge of the horse in **figure F** and you can see what I'm referring to. In addition, the background color and density behind the individual hairs was very different.

Examining the details of an image at 600% is very different than seeing a composite in its entirety, so I wasn't sure how the horse would look when pasted into a new background. Therefore, I went around all the hair as well as the detail in the model's clothing until I had completed the path. I then converted the path into a selection as explained above, and I made sure I saved the selection so I never had to spend another two and a half hours on this again.

When you save a selection, it becomes an alpha channel and you can see it in black and white at the bottom of the Channels panel (**figure G**).

LAYERS	CHANNELS	PATHS	
👁	RGB		⌘2
👁	Red		⌘3
👁	Green		⌘4
👁	Blue		⌘5
	Alpha 1		⌘6

figure G

Pasting In

The next step was simple. I chose a beautiful waterfall for the new environment (**1.3**). This was taken in Oregon, and it was originally shot on daylight-balanced Fujichrome Velvia film in the 1990s. Since this was in deep shade, it became very blue. I didn't use a filter of any kind to create this color. In fact, many photographers in the past used a warming filter when shooting Fuji slide film to eliminate the blue cast. Today, by manipulating the Temperature slider in Adobe Camera Raw or Lightroom, you can bring the color back to what you saw. However, I liked the blue color, and I think it works perfectly for the unicorn idea.

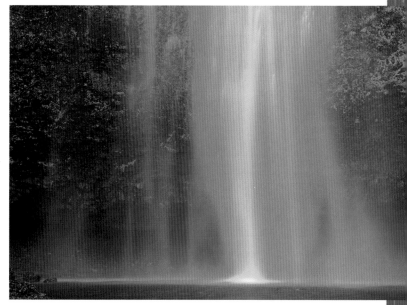

1.3

figure H

figure I

figure J

1.4

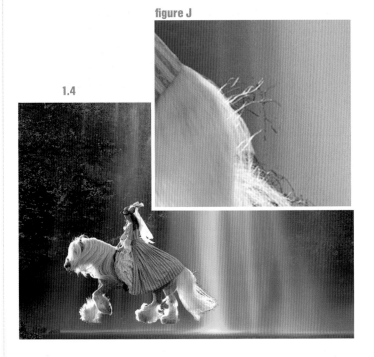

With the original photo of the horse and rider open in Photoshop (figure H), and with the selection around the horse activated so I could see the marching ants, I used Edit > Copy to place the image in Photoshop's temporary holding area, the clipboard. One picture at a time can be held, and it stays there while waiting to be pasted into another image.

I clicked on the open waterfall picture (figure I) to make it active and then used Edit > Paste. This positioned the horse and rider into the new environment. Then, I turned them around to face the other direction using Edit > Transform > Flip Horizontal (1.4). Immediately, though, I saw a major problem.

Too many hairs looked brown, and that made this composite completely unbelievable. Look at the screen capture of a detail of the tail, figure J. This is obviously unacceptable. There was no way I could have selected a narrower part of the individual hairs to make this look right, and I didn't want to lose this important detail because it is this type of thing that makes composites look real—if it's done well.

The Solution

I thought about this problem for an entire day, trying to come up with a technique to make the dark areas of the horse's hair appear to be uniformly backlit. Finally, I came up with an idea that I thought might work. I reasoned that each individual hair, being blond and backlit from a low-angled sun, was basically solid white or close to it. This is considered "blown-out highlights" (i.e., white with no texture or detail, due to overexposure). When I enlarged the original image to 300%, the backlit hair did, in fact, look solid white. Therefore, couldn't I use the Dodge tool to go around each hair and lighten those dark edges?

I tried the first few hairs and it worked like a charm. This took another hour, but it solved the problem. I was able to paste the horse and rider into another background and each hair looked beautifully backlit without any telltale evidence of being cut out.

Using the Move tool in the Tools panel, I moved the horse in place and used Edit > Transform > Scale (short cut: Ctrl/Command + T) to size the subject to taste.

The Reflection

The next step was to add the reflection. I did this by using the Photoshop plug-in, Flood, made by Flaming Pear. It's an inexpensive plug-in that I think you'll love using, because it gives the most realistic reflections imaginable. Once the plug-in is installed, access it using Filter > Flaming Pear > Flood. In the Flood dialog box (**figure K**), the first step in creating the reflection is to establish the water line. The circle indicates the Horizon slider that controls the height of the water line, and it's a simple matter to place this line so it looks realistic.

Next, there are many sliders that control the amount and the shape of the waves. If you don't want to mess with those, you can click the die indicated by the blue arrow. This is a randomizer; simply click it until you like the ripples in the water.

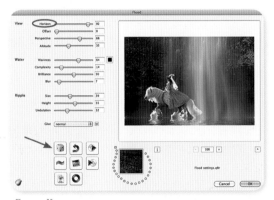

figure K

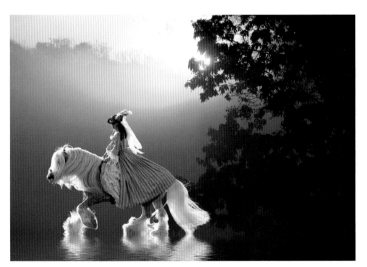

1.6

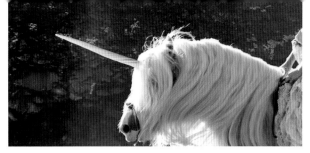

1.5

The Unicorn Horn

To turn the horse into a unicorn (**1.5**), I had to find a unicorn horn. It's not like I could go to the local mall to find one, but the place where you can find anything, including unicorn horns, is eBay. It is actually a cast of a narwhal tusk, and when it arrived, I photographed it against black velvet. When I opened the image in Photoshop, I selected the black background using the Magic Wand tool. I then hit Select > Inverse so that now the only thing selected became the horn.

To make sure the selection didn't have a thin black line, I chose Select > Modify > Contract. In the dialog box that opened, I used a one-pixel Feather. I then copied this selection to the clipboard with Edit > Copy, pasted it into the photo of the horse and rider, and moved it into place using the Move tool.

When you have a floating layer like I did with the horn, by choosing Ctrl/Command + T, you can resize the object. You do this by dragging a corner of the box that forms around the object and, holding the Shift key down to maintain the proper proportions, drag a corner to make the object larger or smaller. However, if you place the cursor outside the box, you can rotate the object. I actually performed both tasks with the horn. It needed to be sized to fit the horse, and then rotated to the correct angle.

Variations

Once the selection of the horse and rider has been saved, it can be used to composite the subjects with another background. Photo **1.6** is an example. I didn't use the horn, but notice the lighting. I placed the backlit subjects in front of the sun, suggesting that this particular sky was causing the dramatic light on the subjects. This works because I matched the light on the foreground with the light coming from the background.

One of the most important aspects of composite work is paying attention to the light and the shadows. If those two things look believable, then the final composite will be convincing.

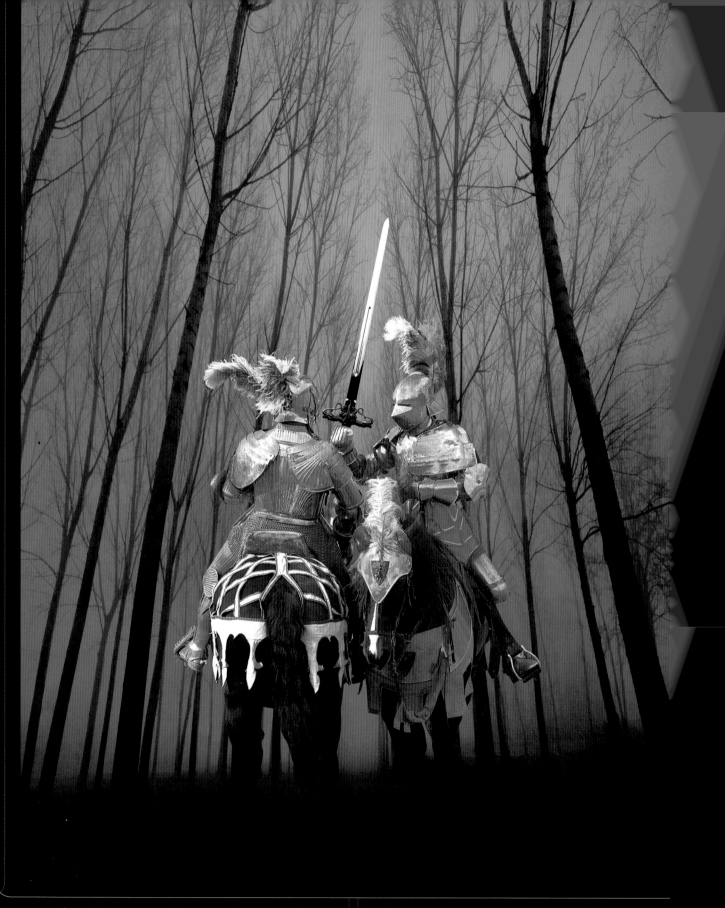

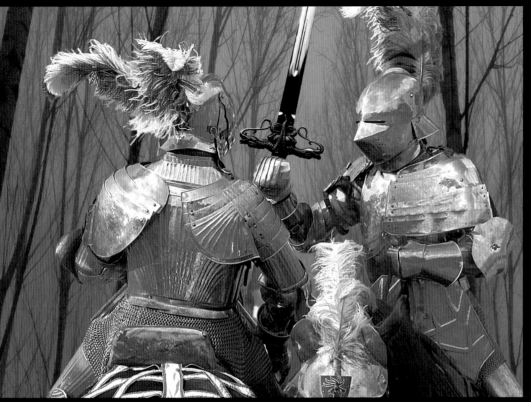
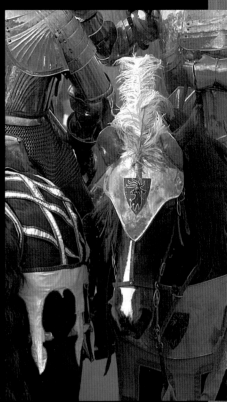

2

MEDIEVAL KNIGHTS

An image I wanted to shoot for a long time was of medieval knights in a foggy forest somewhere in Europe. I went as far as contacting theater and reenactment groups in England to see about arranging this. Even if the cost weren't prohibitive and even if I found the moody and mysterious forest I had in mind, the weather and the lighting would still be unpredictable. Given all the expense and time in setting this up, disappointment was not an acceptable option. Motion picture companies have very deep pockets to create anything they want. My pockets aren't so deep.

A few years ago when I was in Italy, I checked out of a small hotel in the countryside at six o'clock in the morning and was greeted with dense fog just outside the front door. The rows of bare trees (this was February) looked awesome in the fog, **2.1**, and because it was dawn, the dark and gloomy atmosphere presented a unique opportunity.

The White Balance (WB) in my camera is usually set to Daylight. This produces the best colors for outdoor photography, especially when shooting at sunrise or sunset. The colors turn out to be beautifully golden, just as we see them, rather than weak and desaturated, typical of the Auto White Balance setting. However, when shooting in deep shade, Daylight WB tends to give pictures a cool (blue) color bias. When you shoot during dawn or twilight using Daylight WB, the pictures turn out to be a deep, cobalt blue. When I saw the foggy forest on my camera's LCD monitor,

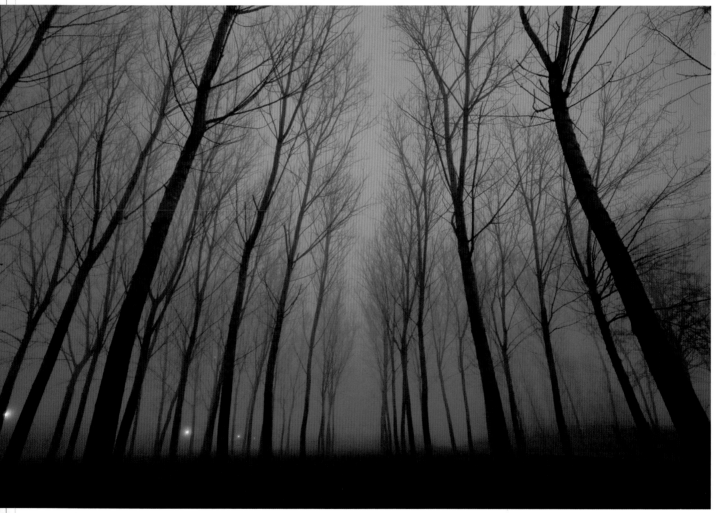

2.1

I thought the blue effect was stunning. I also thought this could be the foggy forest I've been thinking about for the knights. Instead of actually setting up the scene I had envisioned, I wondered if I could make it happen using Photoshop.

The following Spring I went to a local Renaissance Faire specifically to shoot the jousting tournament, where actors compete on horseback in full armor. This gave me the chance to shoot the component I needed. When I shot the picture of two knights on their horses, 2.2, I knew it was the one I was looking for.

Even though I liked the position of the knights and what they were wearing, there were problems. First and foremost, the three o'clock afternoon sun reflecting directly on the armor didn't match the moody lighting of the forest. Second, feathers are very difficult to separate from the background, and although they are not as tough as hair, I had to be meticulous in cutting them out. Third, the horses' tails were dark, and so was the background behind them.

That meant it would be impossible to separate the tails from the background and make it look believable. Fourth, it is very difficult to place feet on the ground from one picture to another. Therefore, I needed to find a way to obscure the bottoms of the horses. And finally, one of the knights was holding a broken wooden lance, and that wouldn't do. Only a sword would complete the picture and give it the magical—and historical—flair I wanted to create.

The Strategy

As I explained in Chapter One, the most accurate method of selecting a subject is with the Pen tool. As I set out to create the image I wanted, my first step would be to use the Pen tool to place anchor points all around the periphery of the subjects as I worked at a high magnification. Then, I would cut and paste the knights into the forest scene and size them correctly. The next step would be to eliminate the highlights on the armor, and then obscure the feet and the tails of the horses. It would be important to match the color of the subjects with the background so this was completely believable. Finally, I would have to buy a sword, photograph it, and place it into the hand of the knight.

The Pen Tool

Using the Zoom tool from the Tools panel, I enlarged the image to 300%. This is the standard degree of magnification I use for selecting a subject unless I'm doing something unusual, like working on hair as I did in Chapter One. I switched to the Pen tool and laboriously traced around the entire periphery of the two horses and the knights. When I got to the feathers, I worked at 400% magnification to make sure the selection was as accurate as possible.

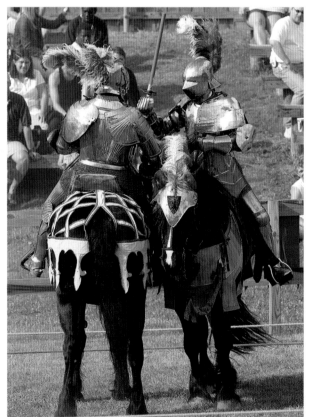

2.2

figure A

In figure A, you can see the string of anchor points along the leg of the horse on the right. The tail is outside of the anchor points, which eliminates it from the selection. Would I rather have included it in the final composite? Yes, that would have been preferable. However, I knew I couldn't make it look perfectly real, so I excluded it.

When I completed the circuit—in other words, once I had meticulously gone all the way around the subjects at high magnification and the Pen tool touched the first anchor point again—the collection of points became a path. As I explained in Chapter One, I converted this to a selection by clicking in the tiny icon in the upper right corner of the Paths panel to access the drop-down submenu there. I chose Make Selection, which brought up a dialog box where I typed 1 for Feather Radius. I left Anti-Aliased checked to smooth the pixels around the curved edges, and I also left New Selection checked to indicate that this was not a modification of an existing selection. Next, I clicked OK to turn the path into a selection, complete with marching ants.

I next used these steps:

1. Select > Modify > Contract (choose one pixel in the dialog box)

2. Select > Modify > Feather (again, choose one pixel in the dialog box)

The first command contracted the selection and helped eliminate the possibility of retaining color from the original background along the edge of the selection. The Feather command softened the selection slightly so the knights would blend with the forest in a realistic fashion. Without feathering the edge, the knights would look like a cutout when examined closely on a computer monitor or in a large print. I then chose Save > Save Selection, followed by File > Save, to permanently save this selection for future use.

Fixing the Blown Highlights

In the diffused and murky lighting of the dawn forest, there would have been no hotspots on the metal armor. There would be subtle highlights, but nothing approaching direct afternoon sunlight. To eliminate the hotspots, I used the Clone Stamp tool. I cloned from adjacent areas of the armor to cover the solid white highlights. This is not a cut-and-dried procedure; it takes finesse, trial and error, and patience.

If you look at the armor closely in **figure B**, you can see there are subtle gradations of tone as well as different colors. Metal, like a mirror, reflects objects around it such as the feathers, the people, the horse, and perhaps a nearby tree. The reflections won't be

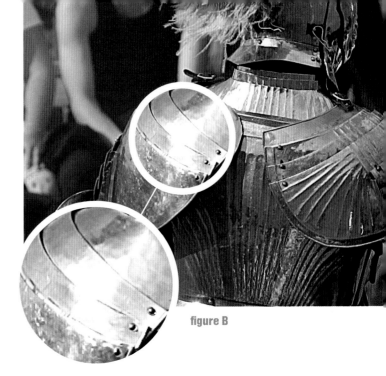

figure B

obvious like they would be in a mirror, but my point is that all of these tones of color can't be disregarded when you start cloning. This is why it's necessary to approach such subtle cloning by using three techniques:

1. Normal cloning with the Clone Stamp tool

2. Using the Clone Stamp tool on a lowered Opacity

3. Using the Healing Brush tool to blend tones together smoothly

To try and explain how this works such that you really see it in your mind's eye would be difficult. Much easier would be for you to see a video showing the procedure. I've uploaded a short clip on YouTube that shows exactly what I've done and how to use these tools with the kind of finesse that makes the result completely believable. This will help you with all kinds of tough composite work. **www.youtube.com/watch?v=qeKHGI1PzJI**

In every cloning situation like this, the available area from which to clone limits you. If the area is very small, it's difficult to do a believable cloning job. In that case, you may have to shoot something else entirely, such as a suit of armor in a museum or at a place like Medieval Times where suits of armor are on display. With this subject, though, I was lucky that I could use the armor that the knight was wearing in the original shot (**figure C**).

figure C

Transforming the Background

The original image was horizontal (see photo 2.1), and there were a few streetlights shining through the fog. I liked the lights, but obviously in a medieval setting, only candle- or torchlight would be available. Therefore, I cloned out the lights while working at 200% magnification. First, I used the Clone Stamp tool, followed by the Healing Brush to blend the subtle blue tones in the fog. The Clone Stamp alone couldn't make this look perfect.

I wanted the final composite to be a vertical picture to emphasize the stature of the knights. To transform the horizontal forest image into a vertical, I opened the Image > Image Size dialog box and unchecked the Constrain Proportions box, (**figure D**). Then, I simply reversed the numbers in the Pixel Dimensions box. I swapped the height and width and hit OK, and suddenly the image was vertical. The result is **2.3**.

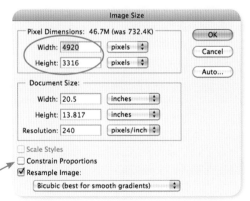

figure D

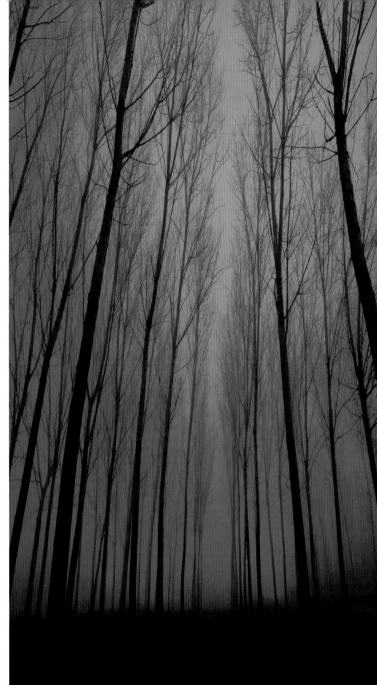

2.3

Obviously, the trees became distorted. They were stretched and look longer and taller than they are in reality. However, when you look at the final composite, they don't seem incorrect. This type of distortion works with subjects that are abstract in proportion, such as trees, clouds, mountain ranges, etc. You can't do this with architecture, people, animals, and many other subjects because they will end up looking ridiculous.

Cutting and Pasting

Once the background was ready for the knights, I activated their photo by clicking on it; and then I selected Edit > Copy. Then, I clicked on the forest background and chose Edit > Paste. This placed the knights into the forest scene as a floating layer, as displayed in the Layers panel, **figure E**.

When you have a floating layer, you can resize it using the command Edit > Transform > Scale. Photoshop puts a box with handles around the image, and then you can simply drag the corners to the preferred size. To maintain the correct proportions, you must hold down the Shift key while dragging the transform box. The ideal situation is to start with a larger image and drag it smaller. You can do the opposite, but keep in mind the floating layer will lose quality if you enlarge it too much, causing the background to look sharper than the subject.

Matching Color

The original photo of the knights was taken in afternoon light, lacking the moody blue color that would match the new background. The easiest way to tweak the color was to use Image > Adjustments > Color Balance, **figure F**. I moved both the Blue and Cyan sliders as you can see in the screen grab, and that made the knights look like they belonged in the forest and their armor was reflecting the moody light of dawn.

Once the image was just the way I wanted, with the size and placement of the subject adjusted correctly, I flattened the image using Layer > Flatten Image to save space on my hard drive. Many photographers and Photoshop gurus save all their layers indefinitely, but I don't see any need to do that. However, I do save the alpha channels. Alpha channels are simply selections that have been saved using Select > Save Selection. You can name the saved selection, but if you don't, Photoshop calls them Alpha 1, Alpha 2, etc., for as many selections as you save.

figure E

Blending the Legs

In my opinion, it was impossible to make the horses look like they were actually standing on the ground. I could come close, but it wouldn't pass close scrutiny. Therefore, I obscured the bottom portion of their legs and feet by darkening the entire lower section of the composition. This made it look like there was dense, low-lying fog in deep shadow.

To do this, I made a duplicate layer with Ctrl/Command + J. This is a good idea because it's possible to blend the top layer with the background layer if necessary, and if I make a mess of things, it's easy to trash the duplicate layer and start again without affecting the composite.

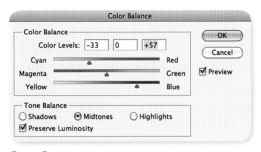

figure F

figure G

Using the Burn tool set at about 60% Opacity, I gradually darkened the legs and hooves of the horses so that the dark tone attenuated into the blue background. This not only solved the problem of showing the horses standing on the ground, but it also added a mystical feeling to the image (**figure G**).

The Sword

The final touch was adding a sword. Knights use wooden lances in jousting tournaments for sport, but in this environment, they might be returning from battle, and they would definitely be holding a sword.

I didn't have a photograph of a suitable sword, so I went online and found a replica that looked medieval on ebay. I paid $35 for it, and when it arrived, I photographed it in diffused daylight to match the soft light in the forest. This is important. The lighting in composites must match, or else the results will never look believable. I angled the sword so it reflected the overcast sky because I wanted it to be highlighted in the final picture.

Using the Pen tool again, I selected the sword and made sure all of that ornate detail was carefully separated from the original background. When the path was complete, I converted it into a selection from the Paths panel as described above, and then placed it in the clipboard by going to Edit > Copy.

The sword had to be sized to fit the image, and for this I used Edit > Transform > Scale again. When the transform box is around the floating layer, placing the cursor outside the box forms a semi-circular double arrow, and this tells you that the subject can be rotated. I rotated the sword so the angle looked good, then clicked OK.

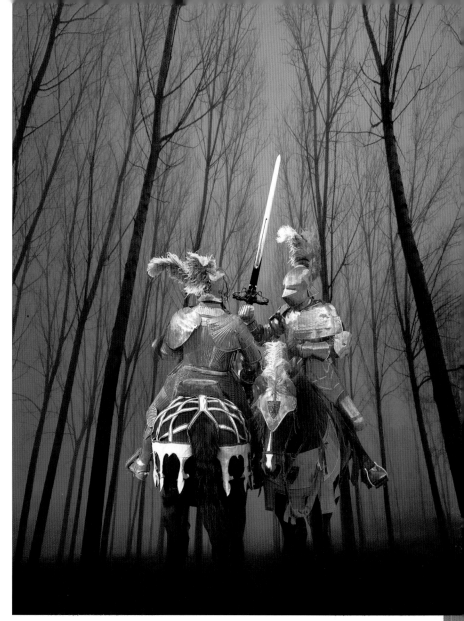

2.4

Using the Move tool, I placed the sword so that the handle was touching the hand of the knight holding the lance. I then went into the Layers panel to activate the background layer and cloned out the lance. Cloning on different layers is easy because you don't have to be careful about getting too close to the edge of another element. In this example, the sword and the lance were on different layers, so when I cloned out the lance, the sword was unaffected.

The last thing I had to do was click on the sword layer in the Layers panel and make a layer mask with Layer > Layer Mask > Reveal All. With the Foreground and Background Color Picker boxes showing black and white, respectively, I chose the Brush tool and painted away the bottom portion of the handle of the sword so it looked like the hand of the knight was holding it.

The final result, 2.4, is one of my all time favorite images.

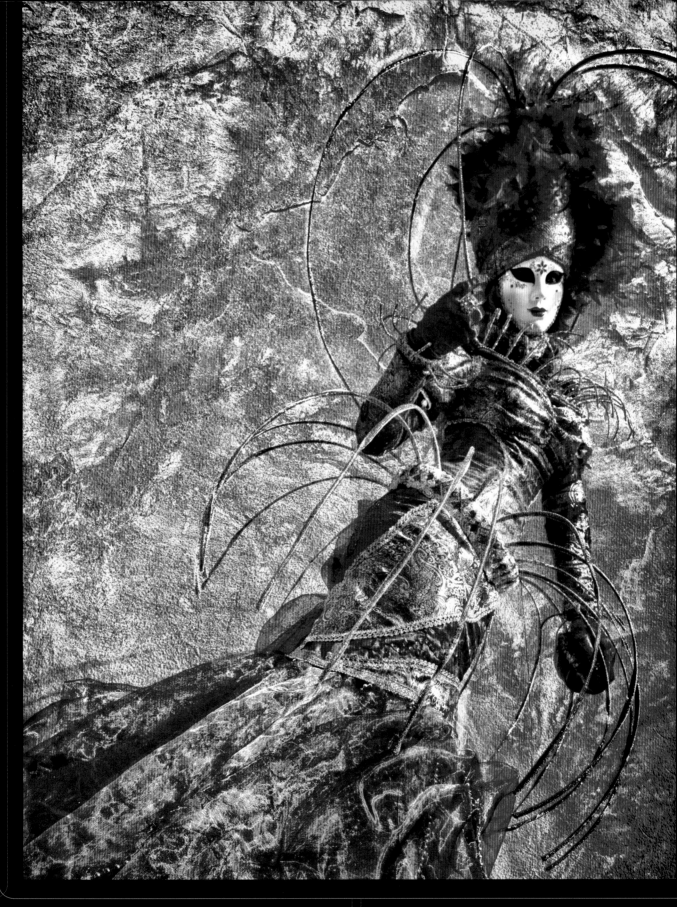

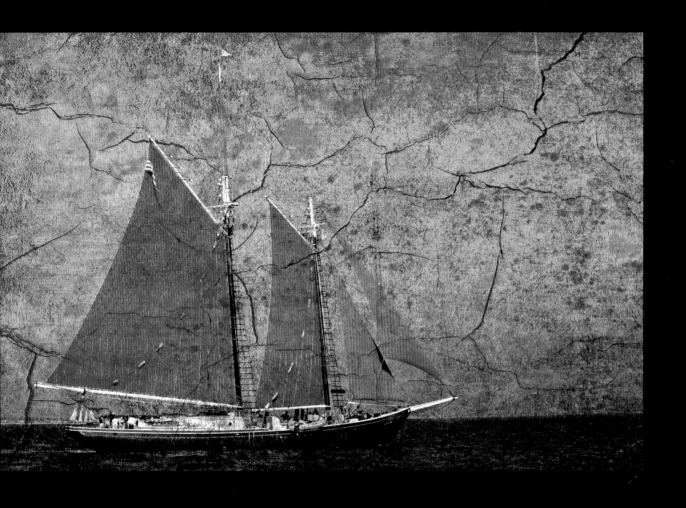

THE GRUNGE EFFECT

call one of my favorite techniques "grunge." This refers to a grungy, coarse, textured look that is combined with an image to make it seem old, artistic, or imbued with a rough texture. There are many types of grunge looks, and you may want to experiment with many of them.

The setting for grunge-type images can consist of many types of backgrounds: from weathered wood, rough stone, textured stucco or cement, to pealing paint, scratched metal, smeared paint on paper, and more. You can shoot your own collection of grunge images, or you can also find them online. Some are free and some must be purchased. If you find free images on the Web, make sure the resolution is high enough to match the quality of your original images. I recommend starting with 30 megabytes (MB) or higher. In my own work, I stick with 40 MB or higher.

My favorite sets of various grunge textures come from Flypaper Textures. The sets I find myself using are Summer Painterly and Spring Painterly. I use them over and over again because they look so varied when combined with different photographs.

Sometimes you will want grunge textures in which the texture is pronounced and seems almost overpowering. I used a rock texture, for example, when I made an artistic statement with a carnival in Venice portrait (page 30). When working with images that are less showy, such as an x-ray of a flower in **3.1**, the texture should be subtler, so it complements the subject.

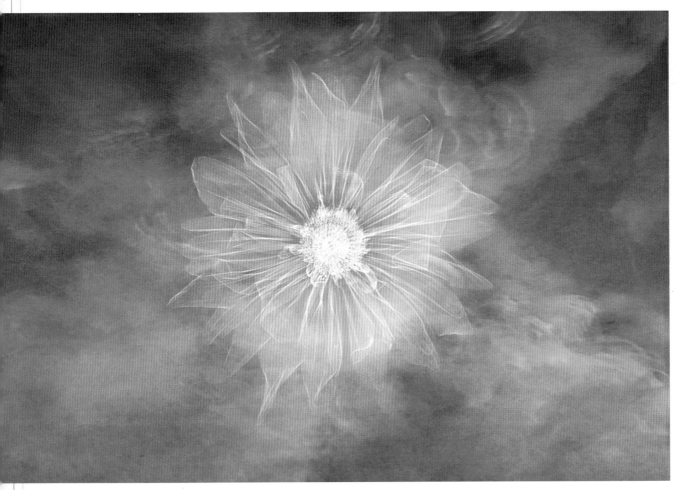

3.1

Choosing Images

Not all photographs are appropriate for this technique. For example, family snapshots taken with on-camera flash, like the one of my wife and dog, **3.2**, simply document a moment in time with little regard to composition, light, etc. and are not even intended to be artistic. A grunge texture doesn't make sense with an image like this, and I doubt you'd be happy with the results if you tried. In my opinion, a photograph of someone smiling doesn't work with a grunge texture or any other kind of Photoshop effect where the end result is supposed to be artistic. The outdoor shot of my son Reynold, **3.3**, is a very nice portrait, but because he's smiling that disqualifies this from working in combination with grunge textures.

3.2

3.3

By contrast, portraits that are contemplative, moody, and introspective make much better material for composite work. Instead of asking for a fake smile when I photographed my neighbor Grayci, in **3.4**, I wanted a more serious expression, and this looks great with the grunge texture I used.

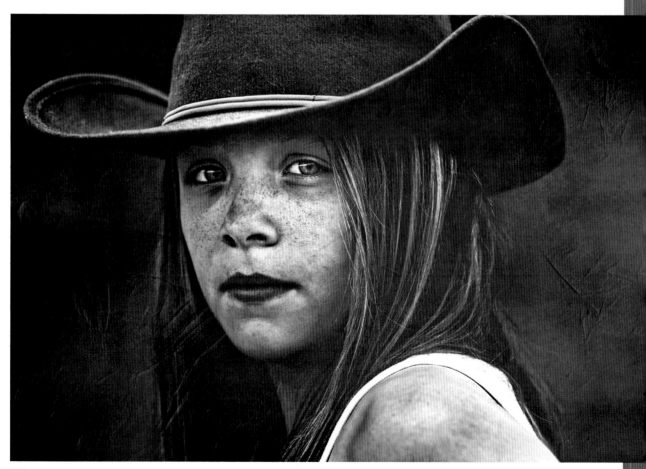

3.4

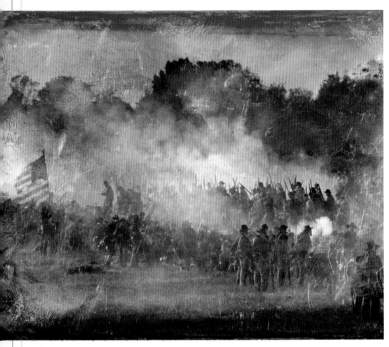

3.5

3.6

3.7

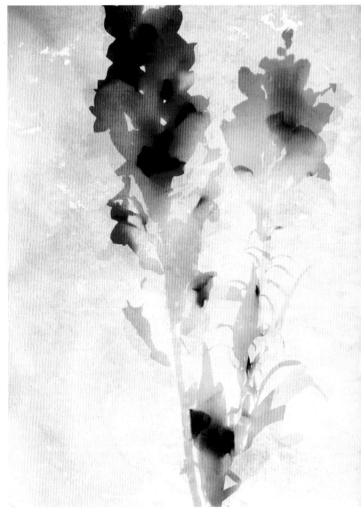

3.8

Many other subjects work well, such as flowers, architecture, tall ships, nostalgic and historical subjects, still life, and land-scapes. I used a scratched metal grunge texture with a picture of a Civil War battle reenactment, 3.5, a technique that made it look like a true vintage photograph. I created a very different look by combining a flower abstract, 3.6, with a subtle texture, 3.7. The flower image is an abstraction I made many years ago in the darkroom. I laid the snapdragon flowers on color printing paper and exposed them to the light from an enlarger. The light went through the flowers and made an impression on the paper that was brought out during development. This is called a *photogram*. The combination of the photogram and the texture resulted in 3.8. I think you can begin to see the remarkable potential in this technique.

The Textures

The first step in creating a grunge photo composite is to choose the original picture as well as the texture. In **3.9**, I've assembled eight different textures from the collection at Flypaper Textures, and this gives you an idea of what they look like, along with the varied possibilities for creating art with your photographs.

These particular textures from Flypaper come as square images. Use the drop-down selections in Photoshop's Menu bar (top of workspace) for Image > Image Size to easily transform them into rectangles by unchecking Constrain Proportions, filling the width and height fields in the dialog box. For example, I currently shoot with the Canon 5D Mark II, and the pixel dimensions of the images that come out of my camera are 5616 x 3744, so these are the numbers I use in resizing the grunge textures to make sure they work well with my photo collection.

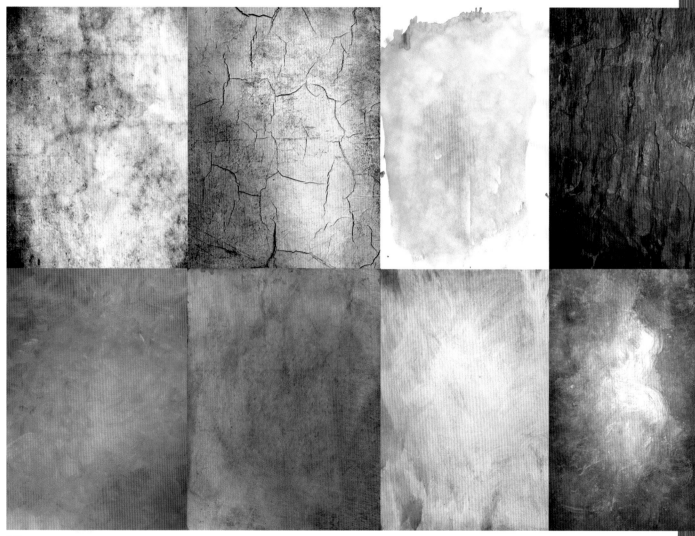

3.9

The Technique

To begin, I make a selection of the grunge texture with Select > All, and then I copy it to the clipboard with Edit > Copy. I then activate the subject photograph and use Edit > Paste. The texture is now floating over the underlying subject. Next, I adjust the Opacity of the texture so some of the subject shows through. This sometimes looks good as is, but usually the best and most artistic composites result from using one of the blending modes.

The blending modes offer ways of combining a floating layer with a background image. To describe what each blending mode does would put you to sleep, and you'd never remember it all. In order to determine if you like the result of blending a texture with a photograph, it's vital to see it. Therefore, you have to try each one, and fortunately, there is a very quick way to scroll through the list.

The blending modes are accessed in the Layers panel. The arrow in **figure A** points to a submenu with the word "Normal" on it. Once you have a floating layer, the list of blending modes are found by clicking on this tab. Instead of using your mouse or Wacom pen to choose one blend mode after another—which gets very tedious quite quickly—you can choose the Move tool in the Tools panel; at that point you can scroll through these modes by holding down the Shift key and hitting the + (plus) key. This method allows you to see at a glance which mode(s) you like.

Some of the blending modes will produce terrible or unappealing images. Sometimes, none of the modes work on a particular combination of photos, but then you'll come across one that is incredible. The Overlay blending mode is one of my favorites, but even that one fails to impress me at times.

Sometimes, I will place an additional grunge texture over the first one if I want an abstract look. For example, the original picture of a tall ship in **3.10** has such a strong graphic shape and saturated color that I thought it would look good with many different kinds of textures. I applied two textures and used the Hue blending mode to produce **3.11**. A very different picture resulted from combining a tall ship that had classic white sails with a subtle texture, as seen in photos **3.12**, **3.13**, and **3.14**. To further dramatize the ship, I applied one of my favorite plug-in filters in Nik Software's Color Efex Pro 4, Darken / Lighten Center. This darkened the periphery and lightened the ship. It's a fairly subtle change, but working with light to focus attention on a subject is something that artists have done for centuries. I first learned about this technique from studying the paintings of Rembrandt.

3.10

figure A

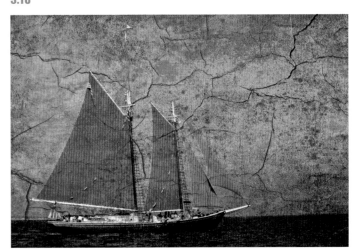

3.11

3.12

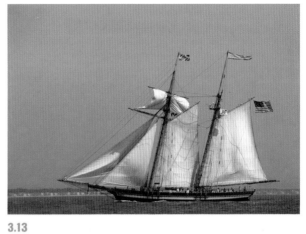

3.13

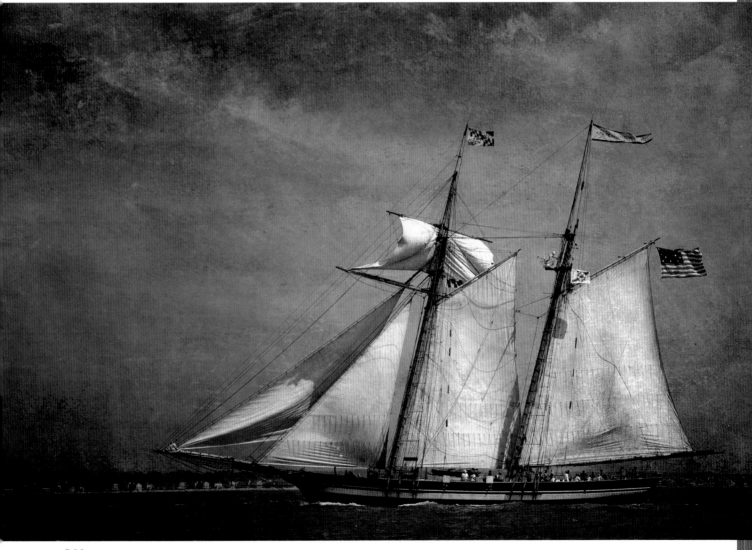

3.14

When you are shooting subjects that already have beautiful artistry, such as the stunning costumes seen during the carnival in Venice, grunge textures are extremely effective. It's almost impossible to predict how a combination of the texture and the subject will turn out, so it's just a matter of experimentation with various textures and various blending modes. The resulting images can be tweaked even more, as I did in 3.14. Images 3.15, 3.16, 3.17, and 3.18 all show composites that I couldn't begin to previsualize before I put these elements together. That's part of the fun—it's always a surprise.

3.16

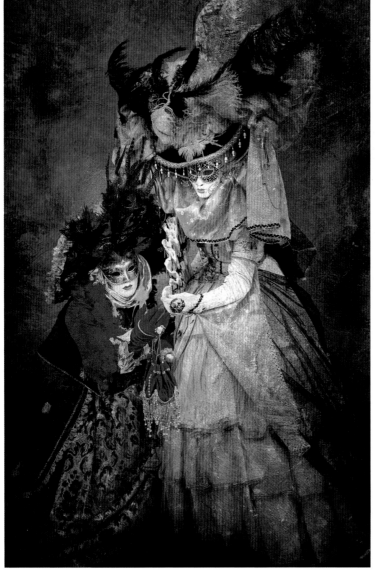

3.15

3.17

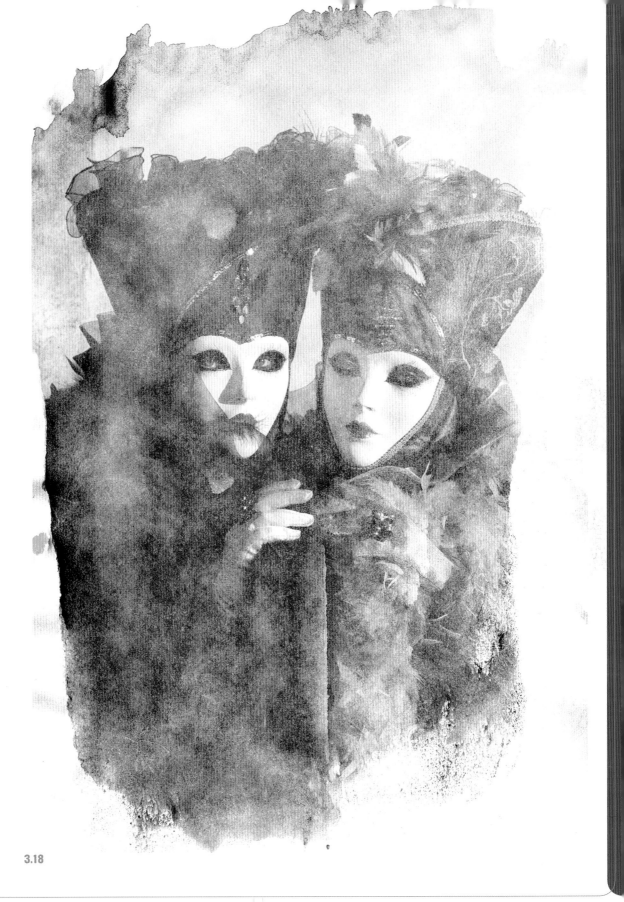

3.18

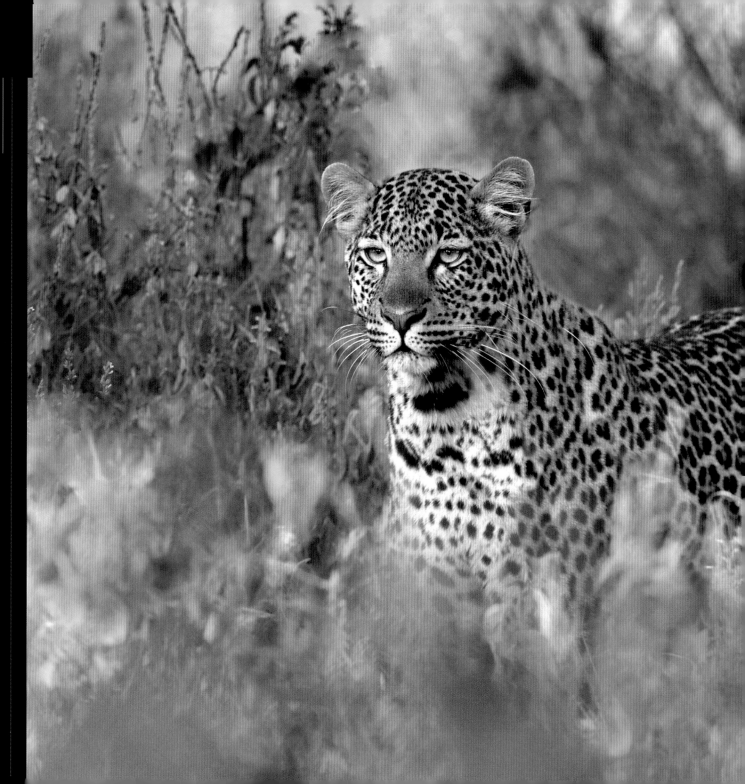

THE LEOPARD

n the first two chapters, I showed how to use Photoshop to create a fantasy image, and in the third chapter I used the program to put images together to create art. Photoshop can also solve myriad problems that are beyond our control at the time of shooting. There are many reasons why we can't capture a perfect picture while recording, such as terrible lighting conditions, a messy background, a bad shooting angle, etc. The capacity to rectify these types of challenges is a huge advantage for photographers.

Take, for example, the picture of a hunting leopard I photographed in the Maasai Mara Game Reserve in Kenya (4.1). It was a great experience to watch the cat stalking an impala, and the intensity of the expression and the magnificent markings make a classic—and rare—photo. However, it was impossible to continually position the land rover to get a clear shot because the leopard was constantly moving to get within striking range of the prey. As a result, the out-of-focus grasses in the foreground are exceedingly distracting. There was simply nothing I could do from my vantage point. I did get other shots of the leopard in a different environment, such as 4.2, which I'm happy with. Nevertheless, I wanted to salvage the picture in which the full concentration of the cat makes a powerful statement.

The biggest problem is the out-of-focus grasses that were lit by the sunrise. Sunrise and sunset lighting are ideal when shooting wildlife (and landscapes), but in this particular case, the leopard was in the shade of a tree while foreground and background areas were lit by direct sunlight. This is problematic because highlights that are lighter than the subject, as in the foreground and background here, compete with the subject for our attention. Our eyes are drawn to the lightest part of a picture first, and that's not what we want if that area is not the subject of the picture, because viewers should be riveted on the subject. If the foreground and background elements are the same tone as the subject (or darker), then they are usually considered complementary.

The Strategy

To repair this image, I decided to crop it, removing a portion of the bright background. That was the easy part. The much more challenging process was to eliminate the bright, out-of-focus grass in the foreground. I could clone out most of it with careful attention to detail, but the ultimate challenge was that one blade of grass in front of the whiskers. Look at 4.3, and you can see what I'm talking about. When you clone something, the area being replaced has to borrow pixels from somewhere else in the photo. There was no other area in this shot that I could use, and to copy individual whiskers from the other side of the face and paste them over the blade of grass was impossible. It would never look believable.

After thinking about this for an entire morning, I came up with a solution that, much to my surprise, worked very well. I simply altered the saturation of the grass (see below) in front of the whiskers to make it virtually disappear. See pages 44-45 for my full explanation.

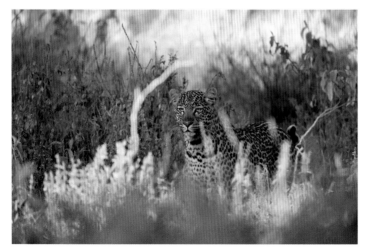

4.1

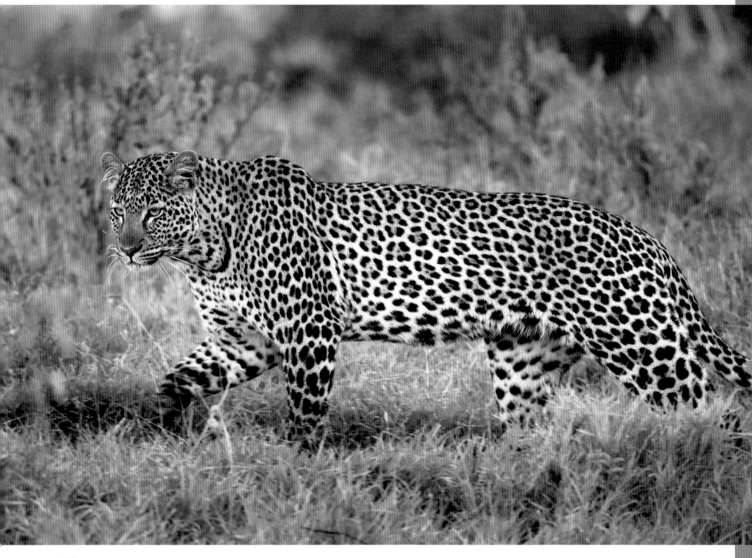

4.2

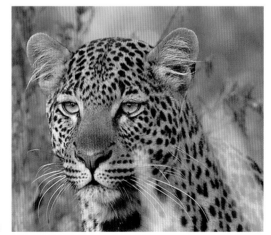

4.3

Cloning Technique

To start, I removed the blurred, highlighted grass that was covering the leopard's body by cloning. I had to find similar spots in adjacent areas with which to cover the discoloration, which was not easy because the types of spots change from the chest to the shoulder and then to the side of the animal. For example, the spots on the chest are black on white, and the shoulder spots are black on a tawny background. On the leopard's side, the spots are beige with a black ring around them set against off-white. In order for this to work, I had to be mindful of these differences.

The technique I employ in cloning challenging subjects like this is to constantly change the source point, or as I sometimes call it, the angle of attack. In **figure A**, you can see that, in order to clone over that large area discolored by the out-of-focus grass, I had to use the Clone Stamp from multiple directions, as indicated by the red arrows.

To clone, select the Clone Stamp tool from the Tools panel, hold down the Alt/Option key (PC/Mac, respectively), and click in an area of the picture—this will be the source point. Now, release the Alt/Option key to start cloning. As you move the Clone Stamp, the + icon follows it (as long as the Align Sample box in the Options bar is checked), constantly showing the location of the source point.

When I clone in a tough circumstance like this one, I will click and then clone many times, constantly changing the source point of the borrowed pixels. (If you don't do this, you'll start to get unattractive and unnatural repeating patterns in the cloned area.) In this way, I carefully cloned out each blade of grass that I found distracting.

The Whiskers

Now for the big challenge: To eliminate the discoloration from the whiskers and the leopard's mouth area, I first tried cloning with a very small brush, but it just didn't work. I tried selecting the individual whiskers, but that failed as well. Finally, I came up with the idea I mentioned earlier: changing the color of the blurred grass.

Using the Lasso tool in the Tools panel, I selected the blurred blade of grass—the part that was covering the whiskers (**figure B**). The edge of the grass was difficult to select, because it was so undefined due to the image's shallow depth of field (I used a 500mm lens plus a 1.4x teleconverter to capture the leopard), so the selection I made along the edge of the grass was fairly rough. From the Menu bar, I chose Select > Modify > Feather and then typed 25 in the Feather Radius box and clicked OK.

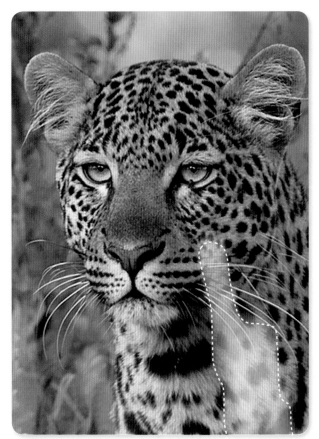

figure B

figure A

Next, I opened Image > Adjustments > Hue / Saturation, **figure C**. In the lower drop-down menu within the dialog box, I selected Yellows and moved the saturation slider to the left. I followed that by doing the same thing with Reds. Golden tones are comprised of both yellows and reds. I was careful not to move the saturation slider too far because that would make the selected area look gray. That's obviously not what I wanted, because it wouldn't blend in with the tawny color of the leopard.

When the color of the grass was mostly desaturated, I used Image > Adjustments > Levels to add a touch of contrast back into this area. The additional contrast helped to make the area that was blurred by the grass appear sharper, bringing back the whiskers that had been lost. In the Levels dialog box, I moved the left slider (circled) to the right, darkening the shadows just enough (**figure D**). By reducing the colors in the blurred grass, I was able to virtually eliminate the dark portions (**figure E**).

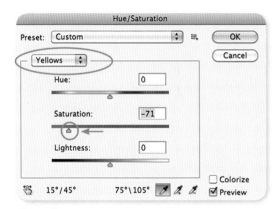

figure C

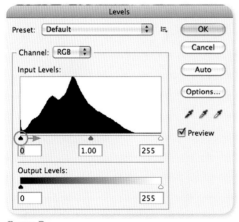

figure D

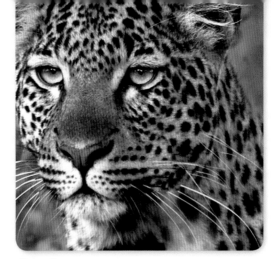

figure E

The Background

The final alteration was to darken the background. There are many ways in Photoshop to tone down a bright area. The quick-and-dirty way is to use the Burn tool, which is hidden behind the Dodge tool in the Tools panel. This is considered destructive editing, however, which means that once you've saved the changes to an image, you can't revert back to the original without making a mess of things (i.e., destroying pixels).

A better way to do it is to make a duplicate layer of the image with Ctrl/Command + J, and then choose the Multiply blending mode from the drop-down menu in the Layers panel. This darkens everything. Then, make a layer mask with Layer > Layer Mask > Reveal All. With black and white in the foreground and background color boxes (bottom of Tools panel), respectively, select the Brush tool and paint away the mask to reveal the original exposure everywhere except where you want the image to be dark. You also have the option of lowering the Opacity of the brush. If the Multiply blending mode darkens the background too much, set an Opacity of 50% or 60% to control exactly how dark a particular area is.

Finally, when an area of an image is darkened, it often seems more saturated in color than it was originally. That happened with the background above the leopard's head. To reduce the extra color, I used the Lasso tool to select the saturated area—which was too yellow—and then I chose Select > Modify > Feather. I opted for 20 pixels. This softened the transition between the area I was working on and the background, and when I adjusted the color, there wasn't an obvious lack of blending.

The last step was to click Image > Adjustments > Hue / Saturation, where I desaturated just the Yellows this time.

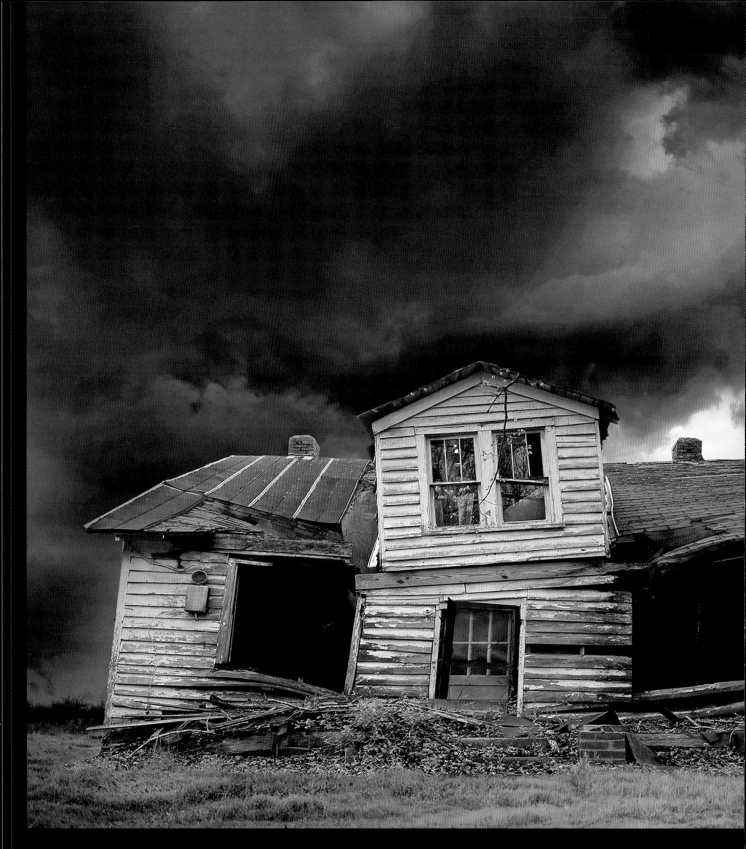

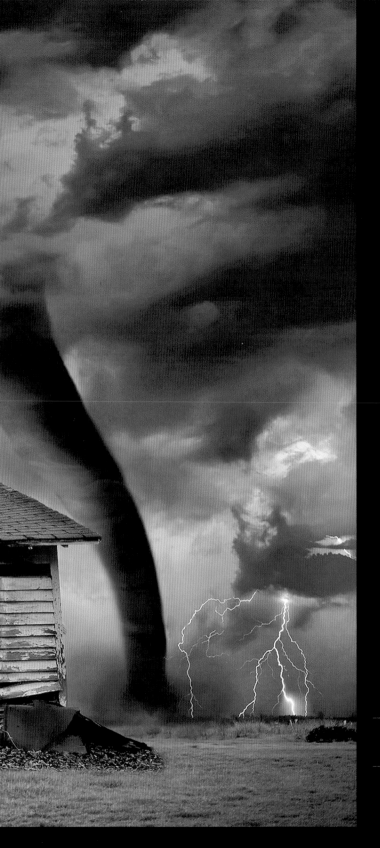

CREATING A TORNADO

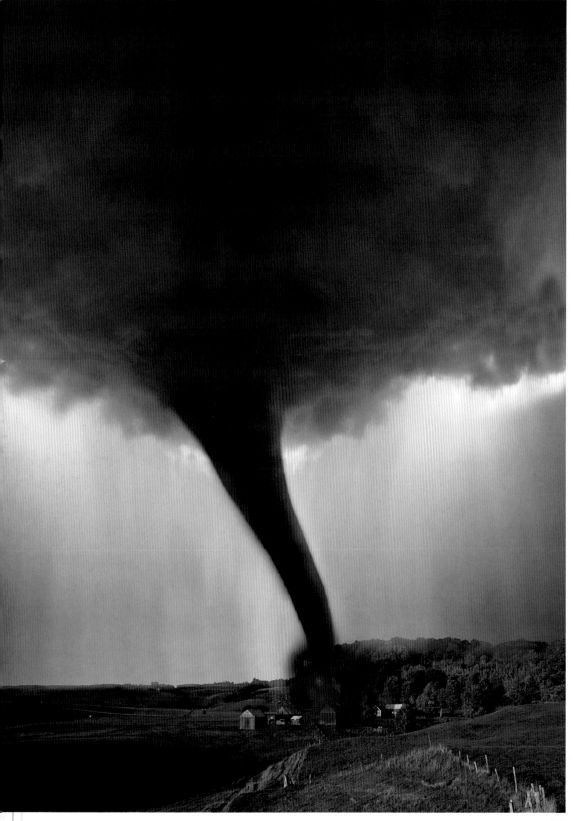

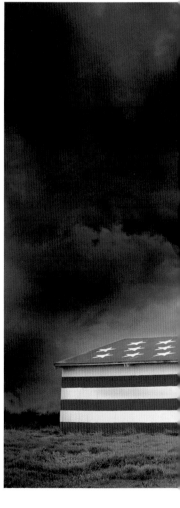

5.1

When the movie *Twister* came out in 1996, my stock agency called me and asked if I could make a tornado. They told me that with the release of the film, they had been getting a lot of requests for tornados and they didn't have any good ones. I told them I wasn't sure I could do it, but I'd try. What I came up with was **5.1**, and from 1996 until now, this picture has sold several times every month with one sale netting $18,500.

I was happy with this image until a short time ago when I became unhappy with it. What was missing, I thought, was that I felt it needed clouds swirling around inside the funnel. Tornados can take many forms, but to make it look as real as possible, I wanted to show a certain amount of striations to suggest the power and drama of what actually goes on inside the storm. My second tornado creation, **5.2**, is superior to the first one in my opinion, although one could argue that the patriotic barn I used for the foreground is a little over the top. To address that issue, I used another foreground—this time a dilapidated old house—and this (**5.3**) is my favorite so far.

Let me explain first how I made the ominous sky, and then I'll show you how I created the funnel and made the striations of tone for the swirling clouds. Finally, I'll describe how to put lightning and foreground elements into a picture.

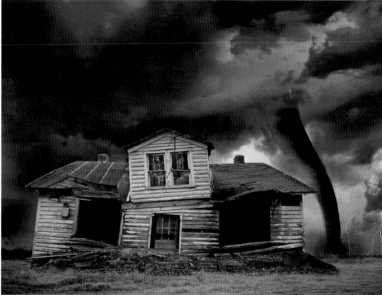

5.3

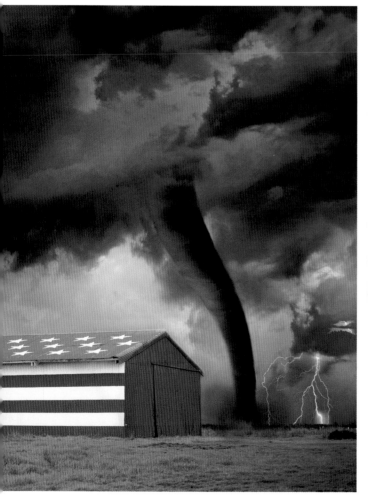

5.2

The Sky

I have a collection of a couple hundred pictures of skies in a folder on my hard drive. I am always replacing unexciting skies in my landscape photos, travel images, and in conceptual pictures like these, where I find that the sky makes a huge contribution to the composite's success. Whenever I see a sky that I think could be used sometime in the future, I photograph it. This includes rainbows, puffy white clouds against a blue sky, sunrises and sunsets, dramatic cumulus clouds, lightning, overcast skies, and of course storm clouds.

I felt that none of my storm cloud photographs was dramatic enough to create the kind of sky that would spawn a tornado, so I combined two different pictures of clouds. To combine clouds, you need to use the blending modes. The procedure is to place one cloud photo over the other, one as a floating layer (Select > All, Edit > Copy), then activate the second image and use Edit > Paste. At this point, you go to the Layers panel and click on the drop-down labeled Normal (**figure A**), and there you will see all of the blending modes (**figure B**).

When working with clouds, there are so many light and dark tones that it's impossible to predict which blending mode will give you the kind of look you want. Therefore, scroll through all of them and see what works best. For the sky I used in the tornado composite, the Overlay blending mode gave me the brooding, threatening type of sky I wanted. At this point, I flattened the layers with Layer > Flatten Image because these individual clouds layers didn't need further manipulation.

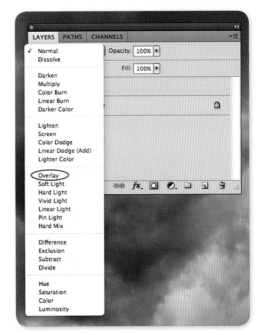

figure B

figure A

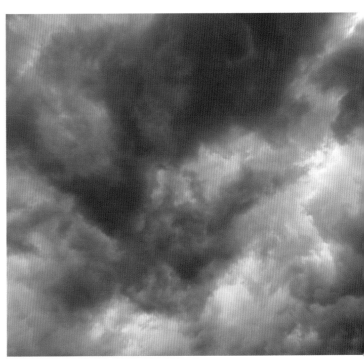

5.4

The Funnel

I saw the movie *Twister* three times to study the shapes of the tornados that millions of filmgoers were seeing, and then I searched online for photographs of real tornados. I finally decided on a particular shape, and in the landscape background I used (a farm scene from Vermont), I proscribed the general form of a funnel with the Lasso tool. This took a few attempts because I have no drawing skills whatsoever, but I finally got what I wanted. I feathered the edge of the funnel using Select > Modify > Feather, and in the dialog box that opened, I chose 20 pixels. This made the edge of the funnel just soft enough in a 60-megabyte (MB) file. If you are using images in the 30- or 40-MB range, I recommend using a 10- to 15-pixel Feather.

The next step was to clone the stormy clouds into the funnel. I did this at 100% Opacity with the Clone tool. (The Opacity box can be found in the Control panel when the Clone tool is selected.) When the Clone tool is selected, you can define how hard or soft the edge is in the Brush box in the Control panel. (This is a drop-down with a brush symbol or dot followed by a number below it.) I chose a brush that was 20% hardness. This choice wasn't a function of experience as much as it was a trial-and-error decision. Also employing trial and error, I cloned and re-cloned until I got a funnel that looked good to me. I certainly didn't want it to be monochromatic because a real tornado has shades of color and a lot of light and dark tones. In 5.1, you can see some subtle shading in the funnel, but as I mentioned, this didn't look good to me after a while (even though it was continuing to make money), and that's when I wanted to raise the bar.

I saved the selection that I had made with the Lasso tool using Select > Save Selection. This gave me the ability to use it later when I put in the swirling clouds.

In order to blend the top of the funnel with the clouds, I used the Clone tool on a lowered Opacity. I deselected the funnel selection and used various settings between 40% and 70% Opacity on the Clone tool until the sky and the funnel merged.

The Striations

It took me a while to figure out how to make bands of clouds apparently swirling around in the funnel. In the end, it was pretty easy. I selected a cloud photo like **5.4**, that had significant contrast between the highlights and the shadows, and I chose Select > All. Then I used Edit > Transform > Scale, and this put a box around the image with tiny square handles in each corner and midway along each edge of the photo. You have to look closely to see them (see **figure C**). I grabbed the top center handle and pulled it down to compress the image. I did not hold the Shift key, as is normally done when resizing an image, because I didn't want to maintain the proper proportions. I wanted just the opposite, and that was to alter the proportions and compress the clouds so they became streaks. In **figure D**, you can see this is exactly what happened. Using the Crop tool in the Tools panel, I then cropped out the background color so that only the compressed clouds remained. The solid color in the background, white in my example, comes from the Background Color Picker at the bottom of the Tools panel. It doesn't matter what color you get because it's eliminated at this point. I saved this image using File > Save As to keep it as a component.

figure C

figure D

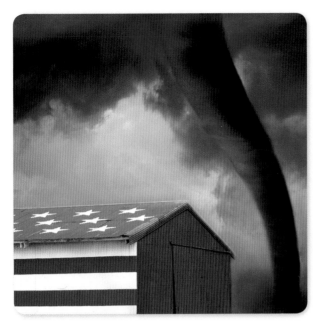

figure E

To add the striations inside the funnel, I activated the saved selection by going to Select > Load Selection. The marching ants appeared around the funnel, and now I could paste the compressed clouds into it.

I selected the striations (the now compressed clouds) with Select > All, and then copied this image to the clipboard using Edit > Copy, Photoshop's temporary holding place for one photo at a time. I activated the tornado photo and used Edit > Paste Special > Paste Into. This is the CS5 command. In CS4 and earlier versions, it's Edit > Paste Into.

The compressed clouds were much too large for the relatively small area of the funnel, and therefore I used Edit > Transform > Scale to resize them. This time, I held the Shift key down and used one of the corner handles to constrain the proportions of the already compressed clouds. I then repeated this process to fill up the height of the funnel, and to prevent the same pattern of clouds from appearing to be duplicated, I used the Move tool to get two different sections of the compressed clouds.

The clouds were now a floating layer, and using the Opacity Slider in the Layers panel, I blended the streaks of tone and color with the underlying clouds that comprised the funnel. Now the funnel gave the impression that it was swirling (**figure E**).

The Lightning

Lightning is sometimes associated with tornados, and I wanted to add this component for additional impact. Before I explain how I added the lightning in Photoshop, let me first tell you how I photograph it.

The easiest way to shoot lightning is to do so at night. If you do it during daylight hours, you need a lightning trigger because it happens too fast to capture simply relying on hand-eye co-ordination. I've tried many, many times to shoot it this way during the day, and I've only captured one lightning strike in years of trying.

At night, you leave the shutter open and wait for the bolts to occur. It's as simple as that. I use a lens in the 100 to 200mm range. If you use a telephoto, you capture a narrower part of the sky. This means you can miss the bolt if it is a few degrees to the left or right. However, if you use a wide-angle lens thinking that you'll encompass most of the sky and therefore you won't miss any of the action, the problem is that the lightning will be very small in the frame. My compromise, then, is to use a zoom lens set to about 150mm, depending on how close I am to the storm.

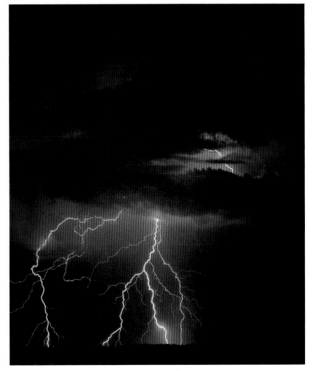

5.5

I use a tripod and an ISO of 100 or 200 to minimize digital noise. The lens aperture that gives the most consistently correct exposures is f/8. If the storm is intense and the lightning bolts are overhead, use f/11. You will have to focus manually—take the camera off autofocus. I focus on a distant ridge or some landform or architecture far enough away that it is considered infinity according the scale on the lens. The exposure mode must be set to manual. Also, if your lens has image stabilization, turn that feature off or the pictures more than likely will not be sharp.

Use a 30-second exposure. If nothing happens during that time, simply open the shutter again and make another 30-second exposure. In this way, you will eventually capture lightning bolts.

The image I used to combine with the tornado is **5.5**. As you can see, the lightning filled a significant part of the frame. That's what the goal is, so that when it is used in a composite, it won't look pixilated.

I never use fake lightning generated from software programs because, once you have pursued real lightning, the fake stuff never looks quite right.

It is impossible to separate lighting from its original background and paste it into another photo such that it looks real by using one of the selection tools in Photoshop. The subtlety in the glow around the bolts makes it impossible to cut out. Therefore, you have to use one of the blending modes.

To place the lighting into the sky, I chose Select > All and then Edit > Copy to place the lightning photo into the clipboard. I then activated the tornado image and used Edit > Paste, followed by Edit > Transform > Scale to size the lightning photo down to fit into the background. The lightning was on a new layer, of course. To make the lighting blend perfectly with the sky, I used the Lighten blending mode. As a consequence, the bolts themselves and the light glow remained visible while the darker portions of the image disappeared. This is the secret to blending lightning, fireworks, and the moon into a night sky or a dark background.

The Debris Effect

Tornados often have a debris cloud at their base where the tremendous suction from the storm picks up barns, cars, trees, and even people and animals. You can add a debris cloud to your funnel for effect, if you are so inclined, as I did for 5.1 on page 48. To make the debris cloud, I used the eyedropper tool to select a dark tone in the clouds. This placed that color in the Foreground Color Picker box at the bottom of the Tools panel. I then selected the brush tool and, using 45% Opacity, I brushed an area at the base of the funnel to suggest dust. Of course, dust had more tones in it than one monochromatic dark gray color, but once I added more elements, I felt it was believable.

Next, I opened the barn photo, **5.6**, and used the Lasso tool to make a selection of the top of the silo. It didn't have to be ultra precise because it was going to be reduced to such a small size. I reduced the size of the silo before I pasted it into the tornado dust cloud, and I used Edit > Transform > Scale to do that. Holding the Shift key down to maintain the correct proportions, I moved one of the corner handles inward to make the portion of the silo very small. On my computer monitor, it was about ½ inch or so.

I then copied and pasted it into the dust cloud and used Edit > Transform > Scale again to size it exactly as I wanted. Without hitting Enter/Return yet, I placed the cursor outside the box around the silo to rotate it. You can do this at the same time as resizing. In other words, first I resized the silo and then I rotated it, and then I hit OK.

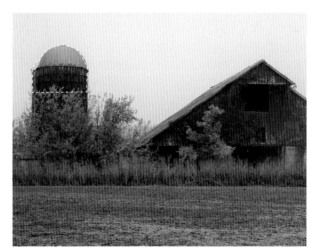

5.6

5.7

Finally, I lowered the Opacity to 22%. I wanted the part of the silo to look like it was inside the cloud of dust rather than simply pasted in front of it. The lowered Opacity accomplished that. I repeated this process for the façade of the barn as well. The detail shot you see in **5.7** shows you what the end result looks like.

The Patriotic Barn

Once the sky was complete with the storm clouds, the funnel, and the lightning, adding a foreground was the last step. The first composite I did was the patriotic barn, **5.8**. I used the Quick Selection tool (it hides beneath the Magic Wand tool in the Tools panel) to make a fast selection of the distant tree line and the building, and then I enlarged the picture to 300% to examine how good a job this tool did. If it wasn't perfect in places, I used the Lasso tool to add or

subtract areas along the selection (holding the Shift key adds to a selection, and using the Alt/Option key subtracts from it).

When I was happy with the selection, I used Select > Modify > Contract. This shrunk the selection, and in the dialog box that opened, I chose one pixel. I wanted to make sure the original background was eliminated from the barn so there wouldn't be a telltale line around it. Next, I chose Select > Modify > Feather to soften the edge of the selection just enough to look correct when the new background was introduced. I used a one-pixel Feather to do this. Two pixels would make the edge look unrealistically soft.

Finally, I placed the tornado in the clipboard, and when the barn photo was activated, I used Edit > Paste Special > Paste Into to place the new sky behind the barn.

The Dilapidated House

When I decided to try another foreground, I used the Pen tool to cut out the old house in **5.9** and then I simply pasted it (Edit > Paste) over the patriotic barn. I darkened the structure as well as the foreground grass to suggest mood and to direct more of the attention to the sky. I used the Burn tool to do that.

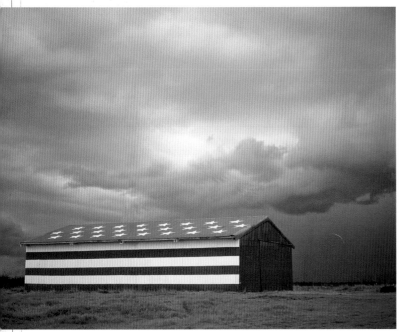

5.8

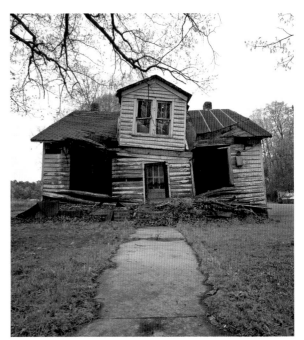

5.9

The Mother of All Storms

Many times when I am working within Photoshop, I carry an image to the nth degree. By that I mean, I keep working it to try and come up with variations on the original theme that have more impact and more drama.

That's the genesis of the photo **5.10**. To create this apparent hellish storm at sea, I changed the color of the sky using Image > Adjustments > Hue / Saturation, and then I applied the Photoshop plug-in Flood, made by Flaming Pear. This enabled me to create a stormy and turbulent foreground.

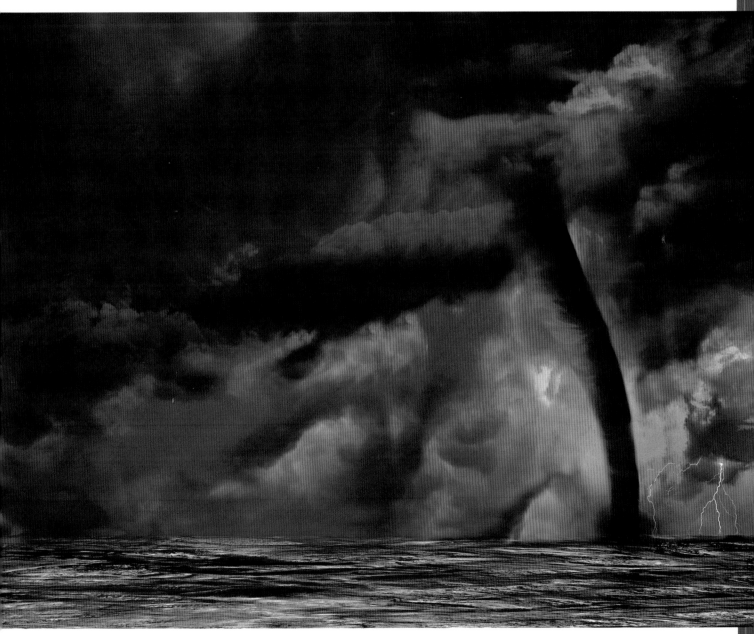

5.10

MAKING A SKETCH

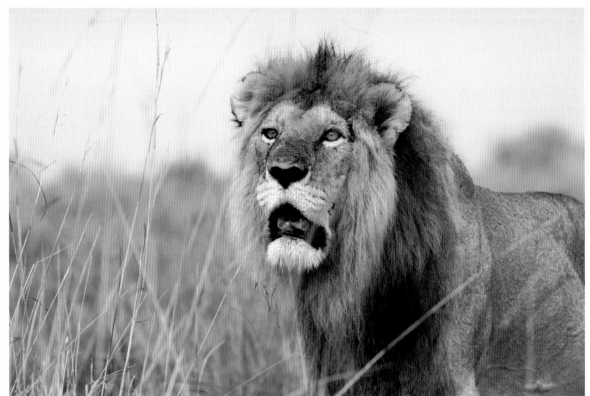

6.1

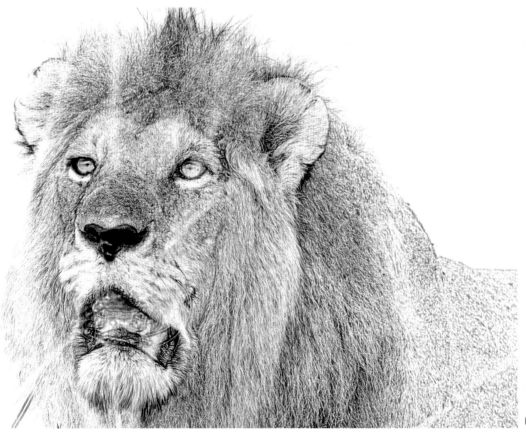

6.2

There is a remarkable technique for turning any photograph into a sketch. It produces a very artistic-looking image, as if you used a fine brush and drew the sketch by hand, and you can even set up an action in the Actions panel to save you from manually going through the steps. I will explain how to do that in a moment.

The comparison photos, **6.1** and **6.2**, illustrate what a remarkable transformation you'll see in your pictures with the sketch technique. You don't have to be constrained to a black-and-white sketch either, because it's so easy—and artistic—to introduce color. The portrait of the Indian women, **6.3**, and the landscape shot (page 56), are examples of color monochrome images I made using the sketch technique.

Here are the steps I use to create sketches.

1 Open a photograph and make a duplicate layer (Ctrl/Command + J). This is Layer 1.

2 With Layer 1 highlighted in the Layers panel, choose Image > Adjustments > Hue / Saturation from the Menu bar. Move the Saturation slider all the way to the left so that the image becomes black and white. Click OK.

3 Make a duplicate layer of the black-and-white image using Ctrl/Command + J, which Photoshop will call Layer 1 copy.

4 With Layer 1 copy highlighted, go to Image > Adjustments > Invert (the short cut is Ctrl/Command + I). This transforms the black-and-white image into a negative.

Figure A shows what the Layers panel should look like at this point. You can see the layers, from bottom to top: the Background layer, Layer 1 in black and white, and the Layer 1 copy that has been converted to a negative image.

5 In the drop-down submenu in the Layers panel, choose the Color Dodge blending mode. At this point, most (or all) of the photograph should be white.

6 Finally, from the Menu bar, select Filter > Other > Minimum. In the dialog box, set the Radius slider to 3 (or to taste).

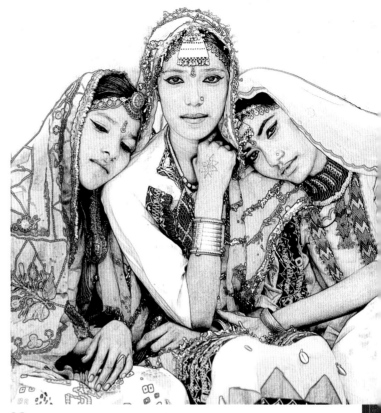

6.3

figure A

figure B

figure C

figure D

The Actions Panel

To make all of these steps happen with a single click of a button, you can set up an Action. If your Actions panel is not open, use Window > Actions from the Menu bar to activate. Here are the steps to create an Action of the sketch technique or any other series of steps you plan to use over and over again.

1 Open a photograph.

2 Make sure your Actions panel is not set to Button mode by clicking the small icon at the upper right-hand corner of the panel (circled in figure B) to open the panel menu. "Button Mode" should not have a check mark next to it; if it does, click it to make the check disappear. (More on Button mode shortly.)

3 Open the panel menu again, but this time, select New Action from the list of choices.

A dialog box opens (figure C) and you can name the action being created. I called mine "Sketch." You can now assign a function button to prompt the Action and a color for its button in Button mode if you wish. You can see in figure D that I've chosen a variety of colors for each of the various actions.

Now, click the Record button in the dialog box to begin setting up the Action. Next, go through the original steps detailed for making a sketch, starting with making a duplicate layer. Make sure the image you are working on has no layers or channels when you begin. When finished, choose Stop Recording from the panel menu or click the tiny square button at the bottom of the Actions panel to stop recording the Action.

At this point, you may enter (or return to) Button mode by selecting Button Mode from the panel menu. I prefer this view to the default List mode, because I find it much easier to read.

You should now see the Action panel with the colored buttons. The last one should be labeled Sketch. Now, when you want to apply the Sketch Action to an image, simply click its button when you have the image open. To apply an Action from the List mode, highlight it, and then either click the Play button (right-pointing arrow) at the bottom of the panel or select Play from the panel menu.

Toning

The sketch you create using this technique will be black and white. If you want to introduce color, use the Menu bar command Image > Adjustments > Color Balance. Using the sliders in the dialog box (**figure E**), you can easily add some toning to the image. The position of the sliders you see here created the red / yellow tone in the sketch of the Taj Mahal, **6.4**.

You can also tone images by converting the sketch to grayscale (Image > Mode > Grayscale), and then using Image > Mode > Duotone. However, I use the Color Balance dialog box because it's much easier and faster.

figure E

6.4

6.5

Blending Modes

You would not think that a blending mode would work well to combine a sketch with the original image, but it's remarkable what you can produce. For example, I used my Sketch Action to turn photo **6.5** into **6.6**. I then selected the entire sketch with Select > All, activated the original, and used Edit > Copy and Edit > Paste to overlay the sketch onto the original. Now the sketch was a floating layer over the color capture, and I produced three artistic variations in **6.7**, **6.8**, and **6.9** using the blend modes Hard Light, Pin Light, and Luminosity, respectively. Of course, you can further tweak the colors using the Image > Adjustments > Hue / Saturation dialog box, as I did in **6.10** and **6.11**.

6.6

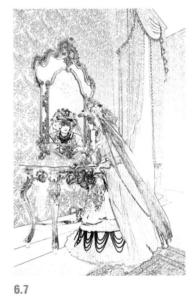

6.7

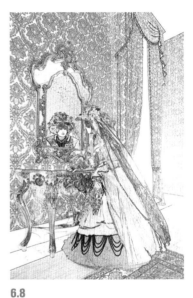

6.8

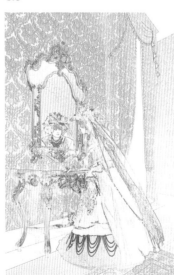

6.9

6.10

6.11

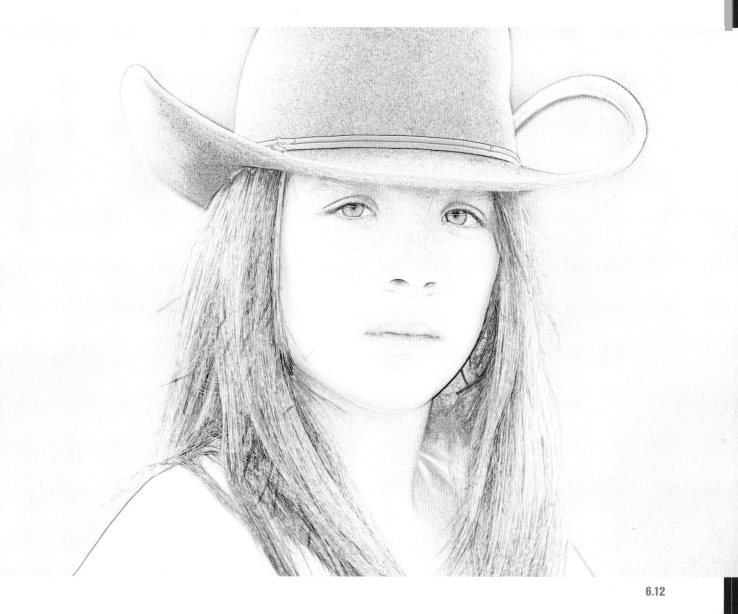

6.12

Combining Black-and-White with Color

A technique that I've been using since the beginning of my involvement in photography is combining color with black-and-white. I used to do it in the darkroom, but now with Photoshop, it's so easy and you have so much control. The portrait of Grayci, 6.12, is an example. After I made the sketch, I selected her eyes with the Lasso tool. I first selected one of them, and then, holding down the Shift key, I selected the other. I recommend toning both eyes at the same time so the color will be exactly the same.

Once selected, I used Select > Modify > Feather and chose a 1-pixel Feather Radius to soften the edge of the selection slightly.

At this point, I opened Image > Adjustments > Color Balance. Assuming the picture is RGB mode and not grayscale, color can be added by moving the sliders in the dialog box. To add saturation once the color has been chosen, Image > Adjustments > Hue / Saturation is the best command to use.

If you are working on a grayscale image and want to introduce color, the easiest way to do that is to use the Menu bar command Image > Mode > RGB. At this point, all of the color commands in Photoshop are available for use.

7

3D SHAPES

Though Photoshop is not specifically designed to create 3D objects, the Extended version contains a number of unique options that allow you to create outside the box—or perhaps outside the known universe. Most photographers don't get involved in 3D because it isn't considered traditional photography and, in some cases, it has nothing to do with photography at all. Instead, it has a lot to do with creating shapes (or importing shapes from a library) and then applying various surfaces to them, and then placing these shaped objects into a scene, which may or may not be photographic. This is what is done in animated films like *Toy Story* and *Shrek*.

One technique that has always intrigued me is to apply two-dimensional photographs onto three-dimensional objects. This chapter will show how you can wrap a photograph onto a sphere. I'll use a native 3D object in Photoshop as an example. First, I will show how you can make 3D objects using the Extended version of Photoshop, and then I will look at a method for those who don't have the Extended version (and for users of Photoshop Elements).

Texture Mapping in Photoshop Extended

The term "texture mapping" refers to wrapping an image onto a 3D object. The image can be applied to the object in different ways. For example, you can take an ordinary photograph like a rose, 7.1, and wrap it on a sphere one time as in 7.2, or tile it onto the sphere, as in 7.3.

The first step is choosing a photograph that will be applied to the sphere. There are endless possibilities, of course. You could choose an abstract, a picture of clouds, autumn foliage, patterns in nature, and a lot more. I will start with a picture of branches I shot in fog in the Great Smokies (7.4). With the photo open, use the Menu bar to select the command 3D > New Shape From Layer > Sphere. After a few seconds, you should see your photograph texture mapped, or applied, to the surface of a sphere. The background will be transparent, as you can see in **figure A**.

You can rotate the photo on the surface of the sphere with the 3D Rotate tool, (**figure B**). When you click on this tool and drag the photo, it can be oriented any way you want. There are tools beneath

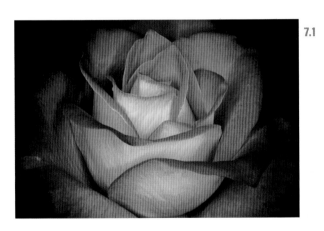

7.1

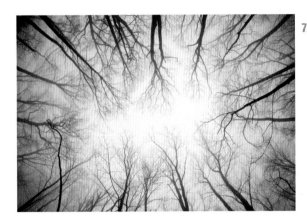

7.4

7.2

7.3

figure A

the 3D Rotate tool that give even more control. For example, the 3D Roll tool allows you to rotate the photo around a central pivot point on the sphere. The 3D Scale tool allows you to change the size of the sphere.

In my experience, the photo always looks dark when applied to the sphere, so I lighten it using the Levels icon in the Adjustments panel (figure C). If this panel isn't open, you can bring it to your desktop using Window > Adjustments. Within the Levels dialog box, move the right-hand slider to the left (circled, figure D) to lighten the highlights. Brighten the image to taste, but be careful not to go too far and lose detail or texture in the highlights. After you finish tweaking the exposure and contrast, you can go back to the Adjustments icons by clicking on the arrow in the lower left corner of the dialog box (arrow, figure D).

Now go to the Menu bar to select Layer > Flatten Image. My image 3D sphere now appears against a white background, figure E. At this point, it's easy to cut and paste this shape into other backgrounds, using it as a unique component in two-dimensional photographs. The sky is the limit in terms of what you can do. When you select the sphere against a white background, use the Magic Wand in the Tools panel to grab the background, and then choose Select > Inverse to select the sphere without the background. Next choose Select > Modify > Contract to shrink the selection by one pixel. This eliminates the possibility of including a thin, tell-tale white line around the sphere. Finally, use Select > Modify > Feather (1 pixel) to slightly soften the edge so that it will not appear unnaturally sharp when the sphere is pasted into a new background.

I have a folder in my photo library with many spheres I've made using these steps. I like to find interesting environments into which I can place them. A few examples on the following page are 7.5, 7.6, 7.7, and 7.8. I used the Flood plug-in from flamingpear.com to create the reflections in 7.5, 7.6, and 7.7.

figure C

figure B

figure D

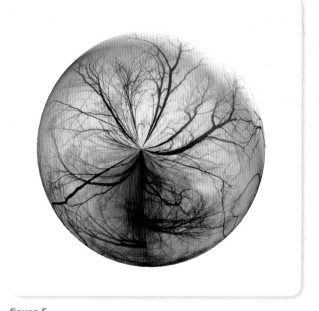

figure E

7.5

7.6

7.7

7.8

figure F

figure G

figure H

Variation on a Theme

There is a way to create a tile effect of a photograph as you wrap it onto a sphere. When you open a photo in Photoshop Extended version, create a tile pattern of your image by choosing 3D > New Tiled Painting. You will now see your image divided into nine smaller but identical images. Next, go to Layer > Flatten Image. Then apply 3D > New Tiled Painting again, and now you will see a tile effect showing 81 images of the photo. **Figures F**, **G**, and **H** show the sequence, from the original photo to the final pattern with 81 tiles.

At this point, you can flatten the image using Layer > Flatten Image and then follow the procedure for creating a sphere as I explained it before. The tiled pattern produces a different kind of look. Examples of how I used the tiled sphere with other elements are shown on page 64, and in **7.9** and **7.10**. All of these images were cut and pasted together using the following steps:

1 Select the component with one of the selection tools (Pen tool, Quick Selection too, Magic Wand tool, Lasso tool), depending on the subject and the background.

2 Use Select > Modify > Contract (one pixel).

3 Use Select > Modify > Feather (one pixel).

4 Use Edit > Copy.

5 Use Edit > Paste (or Edit > Paste Special > Paste Into if you want the selected element to be placed behind something in the picture.

6 Use the Move tool to move it into place and/or Edit > Transform > Scale to change its size.

I don't know why I used the Flood plug-in for all of them, but it just seemed like the digital body of water grounded the sphere, and I liked the look of that. You certainly don't have to do the same thing if you envision something else.

7.9

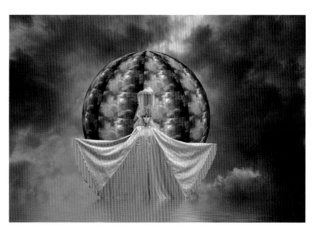

7.10

Option 2: Using Photoshop

If you don't have Photoshop Extended, or if you are working with Photoshop Elements, you can still effectively apply a tiled image to a sphere.

Open your image—I am using a frame-filling shot of peeling paint (**figure I**). Choose Select > All. After that, go to Edit > Free Transform and, holding the Shift key down to maintain proportions, drag one of the lower corners of the box that has appeared around the photo to the upper opposite corner, producing a fairly small thumbnail-sized image. Press Return. The background color will become whatever color is in the background color box at the bottom of the Tools panel. It doesn't matter what color you see because it will be covered up in short order.

The small thumbnail image is still selected, so click on the Move tool in the Tools panel and hold down the Option key on a Mac or the Alt key on a PC and drag the photo off to the side. This creates a clone of the thumbnail. Use the arrow keys to align the clone right next to the original so there is no space between them, as shown in **figure J**. Then, repeat this process until you have five or six (or more if you want) thumbnail images across the page.

Next, select the background color using the Magic Wand tool, and then use Select > Inverse. This will select everything except the background color, which of course is the row of thumbnail images. Repeat the process of duplicating them going down the page by dragging them with the Move tool (and holding the Alt/Option key) until the entire area looks like a tile pattern of the original photo.

Now, select the Elliptical Marquee tool (it is hiding beneath the Rectangular Marquee tool) and hold down the Shift key plus the Alt/Option key. Start from the middle of the image and drag the cursor until you proscribe a circle. Holding down the Shift and Alt/Option keys, constrains the circle so it's perfectly round. If you want an oval instead, don't hold those keys down.

When the circle is drawn, go to Filter > Distort > Spherize. In the dialog box, choose 100% and Normal, and then click OK. The sphere that results will look like it's been texture mapped in three dimensions (**figure K**).

At this point, you can cut and paste the tiled circle into another background. You can also use the Burn tool to darken one edge or one section before or after the shape is pasted into another background to give it a sense of dimension and depth. Photo **7.11** shows how I darkened the bottom portion of the sphere, and then added some flare in the upper section using Filter > Render > Lens Flare. Using the Burn tool, I darkened the stonework to suggest the sphere was casting a shadow.

figure I

figure J

figure K

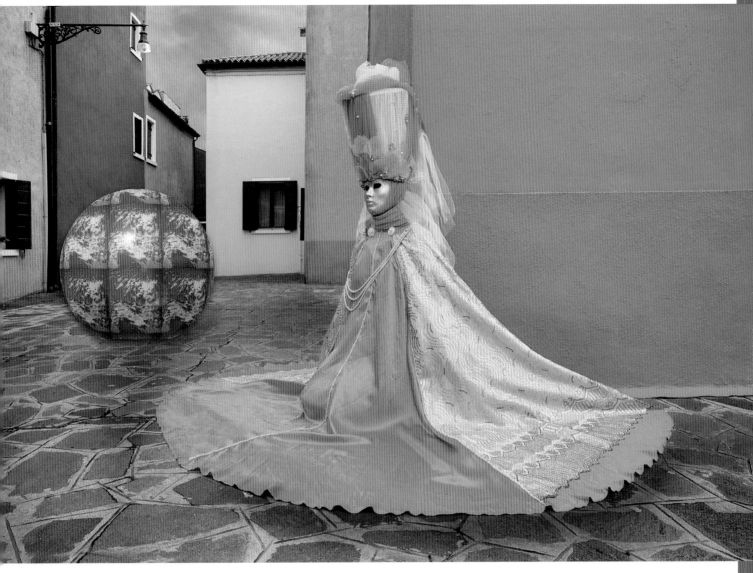

7.11

MAKING A CUBE

have always loved surrealism. After owning a camera for only six months in 1969, I was already experimenting with unusual imagery. Compared to what we can do with Photoshop, though, the tools photographers used back then seem primitive and quaint.

This lesson is merely an extension of my passion for finding new and different ways of making images. I want to explore how to make cubes that are texture mapped and then placed into scenes in unique and artistic ways. Wrapping an image onto a cube can be done with three-dimensional programs, but since Photoshop is primarily a two-dimensional software, we will have to use another approach. You will be able to place more than one image—or different parts of the same image—on the cube using the techniques in this lesson.

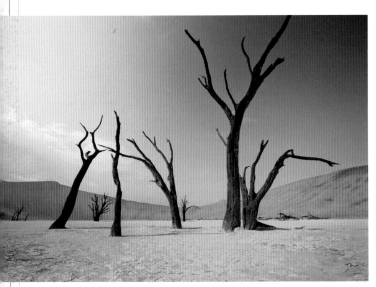

8.1

The Technique

The first step is to choose a background photo, against which you will eventually place a floating cube. As you look for your background image, you can be scouting for images to put on the cube, too. Your background choice could be a landscape, an interior room, an abstract, or anything that appeals to you artistically and conceptually.

Pay attention to the lighting in the cube pictures and background pictures. Don't choose a photo that is too busy with confusing elements that will interfere with the cube. I would also avoid backgrounds with contrasty lighting and extreme shadows or highlights that demand attention and distract from the subject. To start, I've chosen an image from Namibia (**8.1**) as my background.

Open the background and then make a new layer by clicking on the icon at the bottom of the Layers panel (see **figure A**), or use Layer > New > Layer. It will be identified as Layer 1 in the Layers panel. Now, click on the rectangular Marquee tool and hold down the Shift key as you drag the cursor over the photo. The tool will form a perfect square with identical dimensions on all sides.

Click in the Foreground and Background Color boxes at the bottom of the Tools panel and set them to white and black, respectively. Select the Gradient tool from the Tools panel and draw a horizontal line about midway through the square. Your picture should look like **figure B**.

In the Layers panel, you can see the cube against the transparent background in Layer 1. Now make two copies of Layer 1 by pressing Ctrl/Command + J (PC/Mac) twice, so the new layers appear in the Layers panel as Layer 2 and Layer 2 copy. Your Layers panel should now look like **figure C** (the photo itself will

figure A

figure B

figure C

look unchanged). Now, click on the eye icons to the left of Layer 2 and Layer 2 copy to turn them off for the moment, and then click on Layer 1 to highlight it in the list and activate the layer.

Even though we have a perfect square gradient, we now want to change its shape. Choose the drop-down menu command Edit > Free Transform (Ctrl/Command + T is the shortcut), and now you'll see a box formed around the square. You can do this by dragging the lower middle handle up until your rectangle is 90% of the original size. You'll know when it's 90% by looking at the 'H' box in the Options bar, figure D. If your number isn't exactly 90.0 (and it's a challenge to get it exact) simply type the numbers: 90.0. In fact, you may want to skip the dragging altogether and just enter the number 90 in the box. Don't press Enter/Return yet.

Do the same thing for the width: You want the 'W' box to read 70%. Don't press Enter/Return quite yet. Now, choose the drop-down menu command Edit > Transform > Skew. Here again, you can drag the middle handle, but you might find it easier to simply enter −25% in the 'V' box in the Options bar. This changes the angle of the cube, and it should now look like figure E. Press Enter/Return on the keyboard to accept all the Transform values.

We now need to duplicate this shape. Instead of going through that procedure again, activate Layer 2 by clicking on it, and then click on the eye icon so you can see the square gradient again. Use the Menu bar command Edit > Transform > Again, and Layer 2 will change into the same shape as Layer 1.

You won't see that you actually have two shapes until you click the Move tool and drag the top shape off to the side, away from the underlying Layer 1 image. Layer 2 must be flipped to form another side of the cube, so go to Edit > Transform > Flip Horizontal.

Again, using the Move tool, drag the new side of the cube (Layer 2) to connect with the side in Layer 1. Enlarge the photo to 100% so you can see that the two sides join perfectly. You can use the arrow keys to nudge the Layer 2 side until it is in the precise position. Your image should look like figure F.

To put the top of the cube in place, click to activate Layer 2 copy (the top layer in the Layers panel), and make it visible by clicking its eye icon. We want to rotate it exactly 45°, so choose Edit > Free Transform. Hold the Shift key down and put the cursor

outside the box and rotate it. The cursor will change into an icon with arrows that indicate a turning motion. You will find the 45° mark easily—the rotation pauses at that particular point as you are slowly rotating the shape. Move the lid into place so that its corners coincide with the top corners of the side panels. See figure G.

figure D

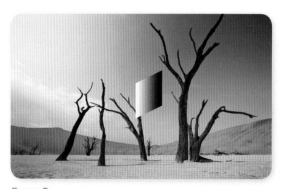

figure E

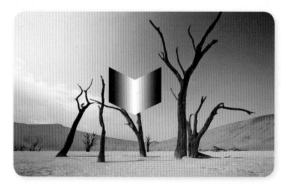

figure F

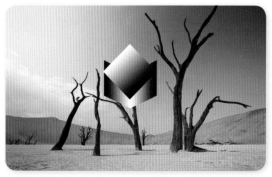

figure G

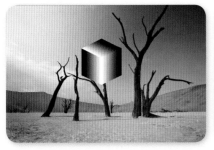

figure H

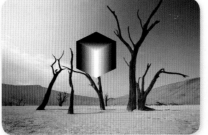

figure I

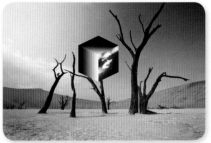

figure J

To pivot the lid so it covers the top of the cube, hold down the Option + Command keys (Mac) or the Alt key on a PC and grab the lower corner of the lid. Raise it up and you'll see the lid pivoting into the correct angle to complete the cube. Click on the Move tool and move it into place. The cube should now look like figure H.

It is normal if the corners don't align perfectly, and you can fix that by enlarging the photo to 100% so you can see the cube in detail. Then select Edit > Free Transform from the Menu bar to pull the corners individually until they line up.

The final step is to correct the lighting on the cube. The top lid isn't quite perfect, so click on the thumbnail for Layer 2 copy in the Layers panel as you hold down the Ctrl or Command key, and that brings up a selection around the lid. This is a cool way to convert any layer into a selection. Now click on the Gradient tool. Drag the cursor from the top of lid to the bottom (assuming the Foreground and Background Color boxes are black and white, respectively), and you'll see the lighting on the lid change to a more realistic look. The light appears to be emanating from the corner of the cube closest to the viewer.

At this point, deselect the selection with Select > Deselect, and save your work so far with File > Save As. My final cube, before the photos are applied, looks like figure I.

Finally, select all the layers in the Layers panel by holding down the Shift key and clicking on each one (all except the Background layer). Then choose Layer > Merge Layers so you are left with the background photo and one layer, which now consists of the assembled cube. If you want to move the entire cube to any part of the background photo, select the layer using Ctrl/Command as I described before, click on the Move tool, and simply drag it to the desired position.

Texture Mapping

Choose a photo to be placed onto the first panel of the cube. I've chosen a sunset photo, 8.2. Select a square section of the photo—the section you want on the cube—by dragging the rectangular Marquee tool and holding the Shift key down. As you may remember, this will produce a perfect square. Make it approximately the same size as the side panel on the cube. Select Edit > Copy from the Menu bar to place the square selection into the clipboard.

Use Edit > Paste to paste the section of the photo onto the cube. It helps to be working at 100% magnification here so you can see that the corners line up. To fit the photo precisely onto the side of the cube, choose Edit > Transform > Distort and drag all four corners of the new photo so that they correspond to the four corners of the panel on the side of the cube. When you think it looks correct, examine the corners to make sure they are perfect. Press Enter/Return. The picture should look like figure J.

For the next panel, you can use a picture with a similar theme, or you can even use another portion of the photo you've already used. Or, you can choose a picture that doesn't relate to the first one. I chose another portion of the sunset image, so I made another

8.2

square selection from it and then selected Edit > Copy and then Edit > Paste onto my background image next to the cube. With the Edit > Transform > Distort command, I pulled the corners of the cloud section to meet the respective counterparts on the cube, just like before. At 100% magnification, I matched them precisely. To match the corners perfectly, it can help to lower the Opacity in the Layers panel to about 50%. After the panel is in place, raise the Opacity back to 100%.

Finally, the lid photo is done the same way. Select a square section of an image, use Edit > Copy and then Edit > Paste, and then with Edit > Transform > Distort, fit the photo onto the lid.

The cube is now complete except for one thing. The gradient created in the beginning, from white to black on each facet of the cube, will help make this look more dimensional and more realistic. Click on each layer one at a time, and then use the Overlay blend mode. The white tone comes through the texture-mapped photo, suggesting that the cube actually has a gradient of light on it.

The last touch is a drop shadow. Everything casts a shadow, even in soft and diffused lighting, so if your cube is hovering over the ground or any other object, you need a shadow beneath it. In my composite, the light is coming from the left (note the long shadows

of the trees) and therefore the shadow would actually be falling to the right.

Click on the Background layer (the photo of the desert landscape in my example) and select the Burn tool. Choose 90% exposure and a fairly large brush with a soft edge in the Options bar. Apply the shadow by brushing along the bottom edges of the cube until you are satisfied.

After I finished the cube composite, I decided that it would look better if the cube was floating behind the large trees in the foreground. Therefore, I merged the layers of the cube to once again make the image a total of two layers (Background layer and cube layer), and then used the Ctrl/Command + click trick from earlier to select the cube. I copied the cube and then opened the original desert landscape, 8.1, and used the Magic Wand tool to select the sky and part of the orange dune in the distance. I then chose Edit > Paste Special > Paste Into. This put the cube behind the trees as you see in 8.3.

For this image, I made the shadow falling off to the right simply by selecting the area that would be in shadow at this time of day when the sun was close to the horizon, and then I darkened it with Image > Adjustments > Levels.

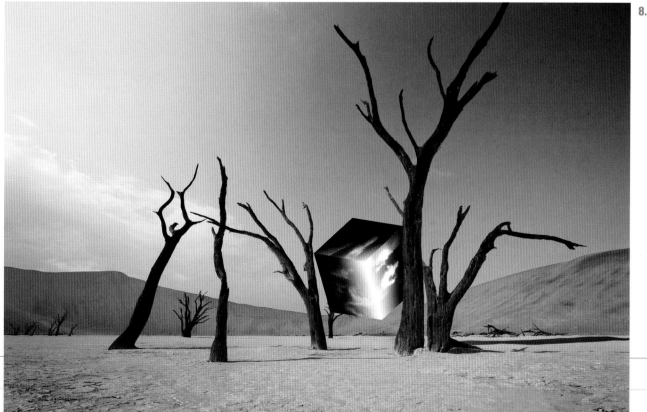

8.3

Variations on a Theme

Why stop here? You can place this cube into other backgrounds to produce very different types of images. Holding down Ctrl/Command while clicking on the cube layer's thumbnail as we have a number of times in this chapter, you can copy the cube to subsequently paste it into any other background you'd like. For example, see images 8.4, 8.5, 8.6, and on page 72. These may give you some ideas for your own work.

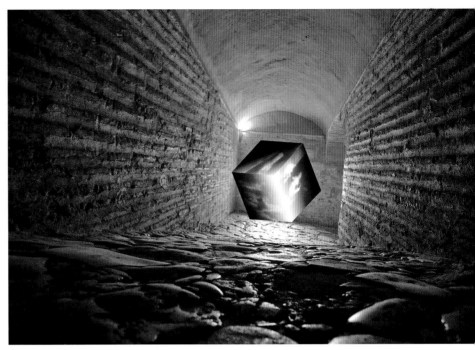

8.4

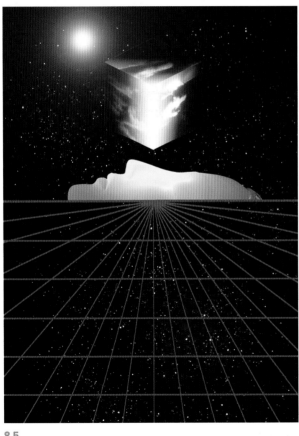

8.5

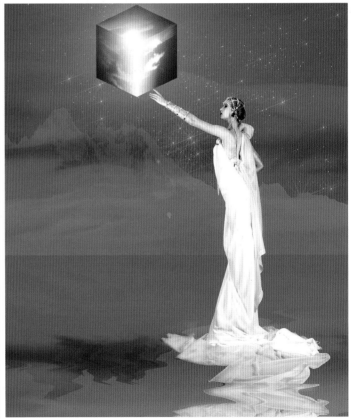

8.6

Open the Box

For a slightly different, more fine-art appeal, you can open up the cube as I did for **8.7**. The photo I've chosen to work with is one I took in Vermont a few years ago, photo **8.8**. There are many types of subjects you could work with from your own files, and once you see the possibilities with this technique, I'm sure you will come up with some great ideas. Consider working with flowers, landscapes, trees, architecture, and cityscapes. I think using a city skyline taken at twilight, for example, could be quite intriguing.

The first thing to do is crop the photo into a square, just like we did to create the sides of our cube. Do this by clicking on the Crop tool, and then hold down the Shift key as you set the parameters for the crop. This forces your crop to be a perfect square. Drag the cursor through your photo from someplace in the top left down through to the bottom right. You can drag the selected square area to any part of the photo until you like what you see. Press Enter/Return.

Alternatively, you can use the command Image > Image Size. In the dialog box that appears, uncheck "Constrain Proportions," **figure K**. Then type identical height and width numbers into either set of boxes, the Pixel Dimensions or the Document Size (the latter is used when you make a print). This will compress the image, and although this causes distortion, in many cases it won't matter. As you can see in the autumn foliage shot, the compressed forest looks quite natural. By doing this, I've avoided cropping parts of the image that I didn't want to lose.

The next step is to make four identical copies of this image. You can do this by hitting Command J on a Mac or Control J on a PC (this is the fastest method) four times, or you can drag the background layer (the photo) down to the "Create a new layer" icon at the bottom of the Layers panel four times. **Figure L** shows all five layers, and the arrow points to the icon for creating a new layer.

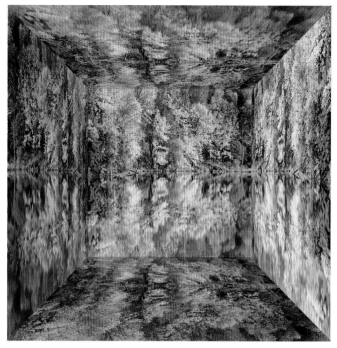

8.7

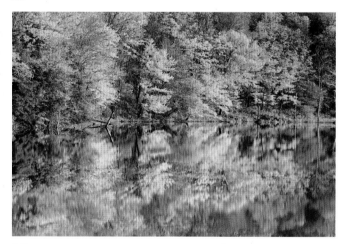

8.8

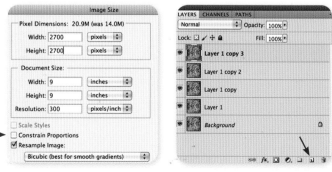

figure K figure L

The next step is to click on the Background layer in the Layers panel, and then open Image > Canvas Size. This command allows you to expand the working area of your picture. In the dialog box that opens, the gray box in the center of the tic-tack-toe represents your photo (Figure M), and the outward pointing arrows show you that the new area you add will go all around the image. That's what you want, so leave the gray box in the center. The unit of measurement in the drop-downs next to the width and height boxes (circled) should be changed to "percent." Type 150 into each of these boxes and click OK. Your picture should now look like figure N. The color that surrounds the photo comes from the background color box in the Tools box, and it doesn't matter what it is because it will be replaced.

figure M

At this point, you want to see some of the extra space you've created in the canvas area. Grab the lower right corner of the document (shown in figure O) by placing the cursor over it and clicking the mouse, and then pull it toward the lower right corner of your screen to see more of the canvas. Now activate Layer 1 by clicking on it in the Layers panel and select the Move tool. With your cursor on the photograph, drag the Layer 1 image to the right. Select Edit > Transform > Flip Horizontal from the Menu bar and, with the Move tool selected, drag the layer 1 image so it adjoins the center photo along its right edge. Your image should look similar to figure P.

figure N figure O

Enlarge your document to 100% to make sure the juncture is perfect when you bring the two images—the center one and its mirror copy—together. You can move the layer in tiny increments by using the arrow keys on the keyboard (as long as the Move tool is selected). Now you can reduce the display size back to 50% or whatever works best for you.

figure P

Now click Ctrl/Command + T; this puts a box with handles around the layer. Drag the middle right handle of the box to the left until the image becomes compressed and aligns with the edge of your working area—i.e., the right edge of the expanded canvas. If you can't get to the handle because the document size won't go any bigger, press Ctrl/Command + –, and then make the document bigger. Now you should be able to reach the handle. Don't press Enter/Return yet.

Choose Edit > Transform > Perspective, and drag the upper right corner of Layer 1 up until you reach 45° as seen in the "V" box in the Options bar. Figure Q shows what you should be seeing—the right panel suddenly gives us a sense of depth. You may now press Enter/Return.

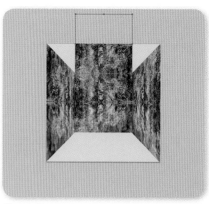

figure Q

figure R

figure S

To put the left panel onto the 3-D box, you do the same thing on the left side that you just did on the right. Activate Layer 1 copy, pull it off to the left side with the Move tool, and then use Ctrl/Command + T and drag that middle left handle to the right, toward the center image, to compress the layer and form the box's left panel. Without hitting Enter/Return yet, select Edit > Transform > Perspective and pull the image like you did on the right side. The same numerical value in the V box is required: −45.0. The result should look like figure R.

To put the top panel in place, activate the next layer copy in the Layers panel, Layer 1 copy 2, and with the Move tool drag it above the center photo. This time, we want to choose Edit > Transform > Flip Vertical so it adjoins the center photo correctly along its top edge. Now use Edit > Free Transform (Ctrl/Command + T) as seen in Figure S to squash the top panel photo down as we did with the side panels, and then again using Edit > Transform > Perspective you can bring the top corners outward until they complete the top panel. If you enlarge the image again with the Magnifier tool, you can make sure the junction between the panels is perfect. If they need a slight tweaking, you can use Edit > Transform > Distort and drag any of the corners into place so they look perfect. Make sure you do this at 100% magnification, though. And of course, the bottom panel is put into place just like the top panel.

I have now completed the open sided box, but there is something about it that isn't quite right. Just like when you paste an object into a scene, the lighting is crucial in making it look real. In this case, what we need is to give the three-dimensional box additional dimension with light and shadow. Therefore, let's activate Layer 1 copy (this controls the left panel) and then choose the drop-down menu Image > Adjustments > Brightness / Contrast. I almost never

use this command, opting instead to use Levels or Curves, but it works in this case because it doesn't introduce contrast as it darkens the panel. Move the brightness slider to the left to about −80. Suddenly you'll see that the depth in this two-dimensional image is more pronounced and believable. You can see how effective this is in adding realism to the composite in 8.9.

Repeat this darkening procedure for the top panel and the bottom panel as well, but I would recommend using a number between 30 and 40—or adjust the exposure to taste. For the right side panel, do the opposite—lighten it so the number on the brightness slider reads about 80. Now you will see the finished open-sided cube with an impressive amount of dimension in 8.10.

At this point, you can flatten the layers with Layer > Flatten Image.

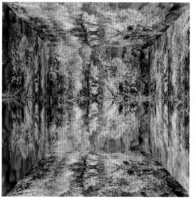

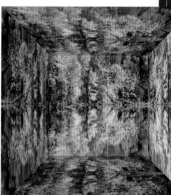

8.9

8.10

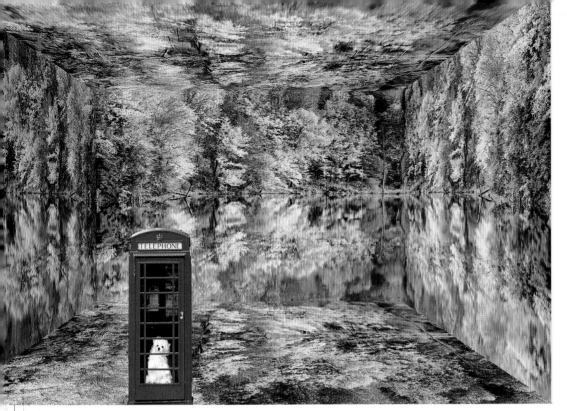

8.11

8.12

Thinking Outside the Box

I have never liked square images much, so I stretched the cube into a rectangular shape by using Image > Image Size and then typing in a new value for the width to proscribe the rectangle. If you are working in a high-resolution file, such as 30 megabytes (MB) or more, stretching the image will still look OK. Because I shoot with the Canon 5D Mark II and get 60 MB files, the pixel dimensions I use are 3744 x 5616, so stretching is no problem at all.

It then occurred to me that the open-sided shape could accommodate another image as if an object or person were contained within it. I first tried a photo of a telephone booth, photo **8.11**. I used the simple cut-and-paste method: I selected the booth with the Quick Selection tool and then pasted it into the background with Edit > Paste. Using the Move tool, I placed the image where I wanted it and sized it correctly with Edit > Transform > Scale. Notice the subtle shadow beneath the telephone booth. I used the Burn tool for this on 30% Opacity and a very soft brush.

Thinking even further outside the box, I put together **8.12**. I started with a straight shot of a remarkable wall of colored windows in the Montreal Convention Center, **8.13**, and I made an open-sided

8.13

box exactly as I did with the autumn foliage, except I did not make it into a rectangle at the end—I kept it as a perfect square. Once the box was made, I then compressed the original photo, 8.13, using Select > All and then Ctrl/Command + T. This put a box with handles around the picture, and by grabbing the center handle on the left side, I moved it to the right until the image was sufficiently squeezed together. I hit Enter, and then copied this image to the clipboard with Edit > Copy. I pasted it next to the open-sided box, and in **figure T**, you can see the two components.

figure T

8.14

Next, using Edit > Transform > Scale, I sized the compressed image to fit exactly against the box. Using the mirror technique from the last chapter, I doubled the width of the image using Image > Canvas Size. I then copied and pasted the open-sided box into the center of each the existing boxes and reduced the size considerably with Edit > Transform > Scale to suggest a diminishing perspective. This is what created such a unique sense of depth. The result is **8.14**.

To create the final composite (8.12), I opened **8.15**. This is a figure I encountered on a street in the tiny European country of Andorra between Spain and France in the Pyrenees Mountains. I thought I might be able to use it as a component in a composite, but at the time I hadn't photographed the Convention Center in Montreal, so I certainly didn't previsualize this combination of images when I took the shot. I selected it with the Pen tool and then turned the path into a selection as I explained earlier in this book (page 18). I copied it to the clipboard, and before I pasted it into the wild background, I used the Rectangular Marquee tool to proscribe a selection inside the small, inner box. I then chose Select > Inverse. This selected everything except the rectangular selection.

8.15

Now it was a simple matter of using Edit > Paste Special > Paste Into. This put the female figure in the wild background in such a way that she appears to be peeking into the colorful room from around a corner. I had to make the pasted-in image smaller so it would appear to be in correct proportion to the rest of the photo, and as I've explained previously, this was done with Edit > Transform > Scale or with the shortcut Ctrl/Command + T. I then repeated this process on the other side to complete the project.

SILHOUETTES

s photographers, we recognize that the power a silhouetted form has to hold a viewer's attention. With a bold background and a subject with an attractive graphic shape, the picture will always be visually compelling. The photo on page 84 and **9.1** (below) exemplify what I'm describing. The leopard in the tree was shot against a huge sun—made possible because I used a 500mm telephoto lens—while the tree silhouette against the mauve sky has the glow of dusk in the background. Both images are striking because the keys to successful silhouettes are bright backgrounds behind dark, shadowy subjects with graphic forms that are artistic, compelling, striking, and beautiful. In addition, the silhouette must be sharp—out-of-focus silhouettes virtually never work.

If the lighting isn't conducive to capturing a silhouette, you can turn any subject into a dark form against a lighter background. However, you have to pay particular attention to the lighting. Let me explain.

Matching the Light

The Taj Mahal photograph **9.2** is a silhouette, but notice that the architecture is not solid black. We can see detail in it, plus some red flare from the brilliant sun. Compare this image with the skyline of San Francisco, **9.3**, where the skyscrapers are black with no detail. Why is there a discrepancy like this?

Two factors influence how a silhouetted subject looks against a light background: atmospheric haze and the angle of the sun. If there is a lot of haze, as there was when I shot the Taj Mahal, then the structure will not be as dark as it would be if the air were clear, because haze disperses light. The angle of the sun is the main factor, though, because the lower the sun is to the horizon, the darker the subject will appear—even though you may be able to see complete detail with your eyes. This happens because the ambient light is reduced so much that the illumination on the subject is several f/stops darker than the sun. When you expose for the sun, the subject in the foreground looks black.

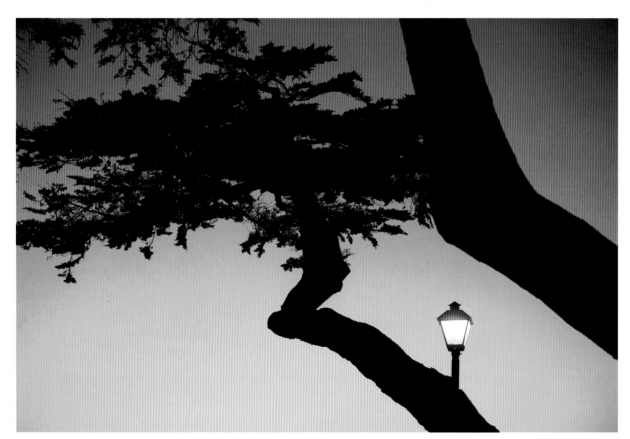

9.1

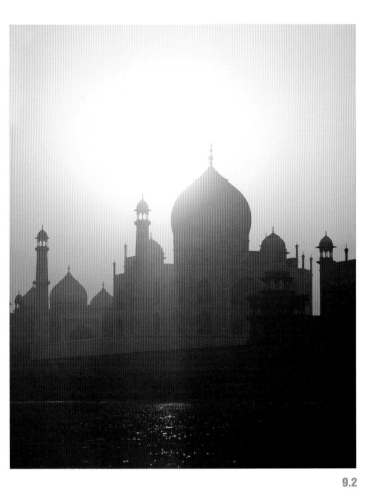

9.2

Once the sun drops below the horizon, the light changes again. If there is a lot of atmospheric haze or dust, contrast will be reduced and therefore a subject placed in silhouette (or partial silhouette) should show some detail, as in the composite of a dinosaur model with a dusty African landscape, 9.4. This is important to keep in mind. Our eye-brain combination is extremely sophisticated, and we can see a dynamic range that is way beyond that of a digital sensor. (By "dynamic range" in this instance, I am referring to the ability to see detail in shadows and the highlights.) If you expose correctly for light areas when you shoot a scene with extreme contrast, such as the sky in the San Francisco photo, then solid areas—the city's buildings—will be dark. This is how film and digital sensors capture light, unless you use the HDR (high dynamic range) technique for recording.

When you turn a subject into a silhouette, and then use Photoshop to combine it with a background, be mindful of the type of lighting in your composite. Does this type of light call for the silhouette to be black, or should it have some subtle tones in it? That's the question.

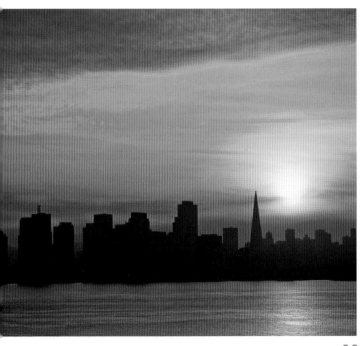

9.3

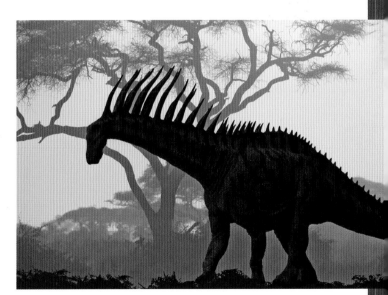

9.4

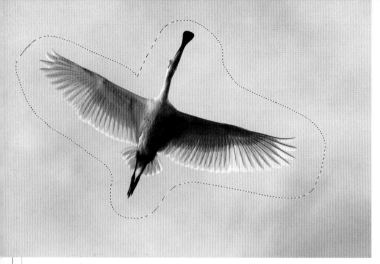

9.5

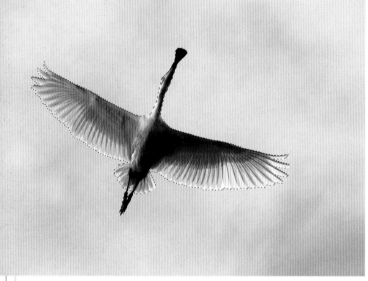

9.6

Black Silhouettes, the Quick and Dirty Method

The first step in making a silhouette out of any subject is selecting it. The selection method depends on the photo itself. For example, if you are working with a bird in flight against a bright sky, it's easy. In **9.5**, I used the Lasso tool to make a rough selection around the Roseate Spoonbill, and then I chose the Magic Wand tool. With the Tolerance set to the default, which is 32 (the Tolerance box shows up in the Options bar when you click on the Magic Wand tool), I clicked inside the selected area in the blue sky while holding down the Alt/Option key (on PC/Mac, respectively). Holding this key subtracts the blue sky from the selection, leaving only the spoonbill selected (**9.6**).

To fill the selection with black, use Edit > Fill. The dialog box is shown in **figure A**. Choose Normal blending mode and 100% Opacity in the Blending box. You can choose either the foreground or background color in the Contents box. This refers to the Foreground or Background Color buttons at the bottom of the Tools panel. I used the foreground color and made that box black, which was then the color that filled the selection in the shot of the spoonbill, **9.7**.

To place the silhouetted form into a background, feather the edge of the selection by one pixel using Select > Modify > Feather (this makes the bird blend naturally with the new background) and

figure A

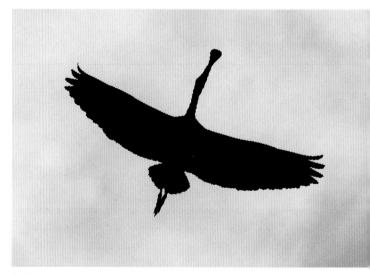

9.7

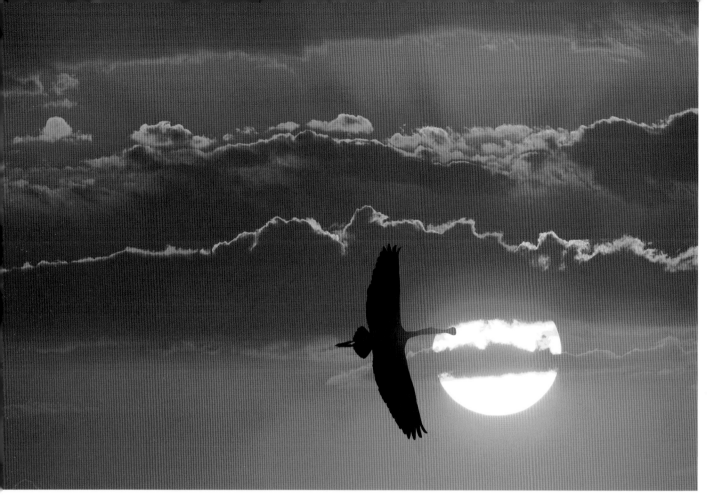

9.8

choose Edit > Copy from the Menu bar. Activate the background image, in this case a sunset sky I shot with my 500mm f/4 Canon lens, and place the silhouette using Edit > Paste.

At this point, you can resize the silhouette using Edit > Transform > Scale, and at the same time change the orientation of the bird and rotate it by placing the cursor outside the box that forms around it. My final composite is **9.8**.

I mentioned how important it is to pay attention to lighting, and there is one thing about this image that I'd like to point out. Many times there is a glow that infuses your subject when you photograph it against a brilliant sun. In other words, it's not solid black, but it also has tones of red, orange, or yellow. Look at the bird's head and bill as well as the front edge of the wing. I added this glow to make it more believable by using the Gradient tool.

The Gradient tool is one of my favorite ones in Photoshop because

figure B

it has so many uses. In this case, I set the tool to the circular gradient by clicking on the second icon from the left in the Options bar, **figure B**. Then I used the Eye Dropper tool to sample the bright orange glow around the sun, which designated that tone as the new foreground color in the box at the bottom of the Tools panel. To put a color in the background color box, you must hold down the Alt/Option key (PC/Mac) and click in another color with the eyedropper. For this example, I chose the darkest part of the darkest cloud in this picture.

Switching back to select the Gradient tool, I dragged the cursor from the beak toward the tail, varying how long this "drag line" was until I felt the glow looked natural. Because I had chosen the circular Gradient tool, the glow was applied in a natural distribution of color.

Black Silhouettes, the Laborious but Accurate Method

When you are dealing with a subject that is not so clearly defined against a background, such as the impala in **9.9**, you have to use the Pen tool. No other selection tool in Photoshop is as accurate and precise. In this particular case, the bottom portions of the legs are obscured in the grass, and it is therefore necessary to define the legs with the Pen tool using the best guesstimate of where exactly they begin and end.

As I described in Chapter One, I use the Pen tool by placing anchor points all along the periphery of the subject I want to outline. This impala took me about twenty minutes. It is certainly not instant gratification like you get with the Magic Wand, but the results will be perfect.

When the path was completed, and I had converted it into a selection using Make Selection in the Paths panel menu (see figure D in Chapter One), I then filled it with black using Edit >

Fill. Following this, I cut and pasted it into an African sunrise background and made it large in the frame for drama, **9.10**. With a different background, **9.11**, I placed two impala cutouts and made them small in the frame, implying distance. Notice in both of these images that the sun is very low in the sky, hence the black silhouettes make sense regarding the exposure that we would expect from a lighting situation like this.

Other Considerations

Sometimes you want to make a silhouette of a subject that has fine detail, such as the ropes on a hot air balloon or the reins on the animals in a camel train, **9.12**. When you make a selection of the subjects, detail can easily be lost. In order to make a silhouette that is believable, you don't want to lose this important detail. For example, in the silhouette of the camel train, **9.13**, I didn't want to lose the reins. It wouldn't make sense.

If these lines are lost, or if they partially disappear, you have to add them back into the shot. If they are straight lines, such as with a

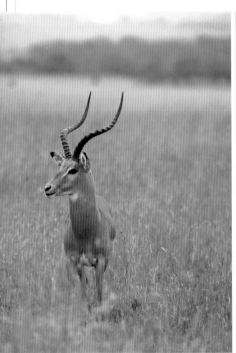

9.9

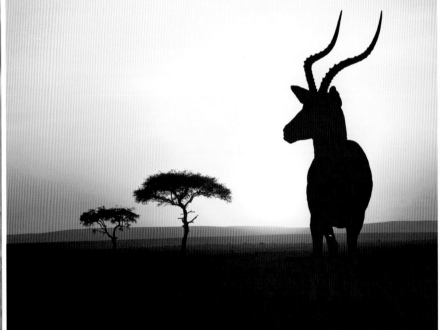

9.10 9.11

hot air balloon, you can use the rectangular Marquee tool to define a very narrow line. I open a new document in Photoshop with File > New, size it to the same size as the photo so the sense of scale is the same, and then I fill the selection with black. It is then a simple matter of copying and pasting that into the shot and placing it where it belongs.

If the line isn't straight, then the best way to replace it is to use the Brush tool on a very small size and paint the black line back into the shot. You'd want a hard-edged brush to do this. The edge of the brush can be defined by first choosing the Brush icon in the Tools panel and then by clicking the Size and Hardness drop-down (circled, **figure C**) towards the left side of the Options bar. This opens a panel where you can move the Hardness slider (arrow) to make the brush harder or softer. You can also use the size slider to control the size of the brush. A shortcut, though, for changing the size of the brush (as well as for many other tools) is to use the Bracket keys on the keyboard. The left bracket makes the brush smaller and the right bracket makes it larger.

figure C

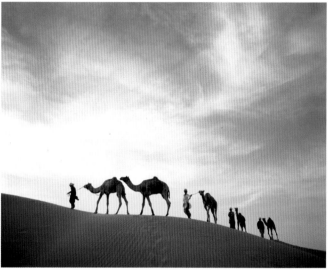

9.12

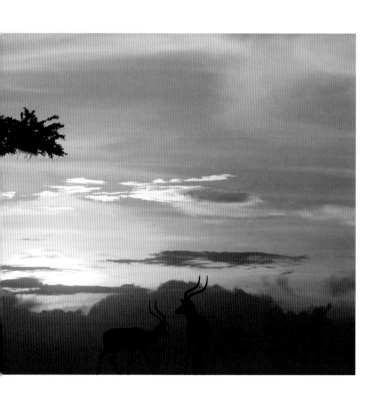

9.13

9.14

Using a White Background

There is another, unique way of creating a silhouette and dropping in another background, which involves a different approach. A picture I created about 25 years ago using film, 9.14, remains one of my all-time favorites. I hired a horse trainer who had a horse that reared on command, and I took several pictures of it against a white, overcast sky. I got down low and shot upward because that gave the horse greater stature, and it also positioned the animal against the sky without any distracting elements behind it. Because this was taken before digital photography and Photoshop, it was not possible to clone out unwanted elements in the background.

When I combined the original 6 x 7cm medium-format transparency of the horse with a shot of lighting, also taken with the same format, the result was perfect. This technique is called sandwiching, where two slides are placed together and then re-photographed, or copied, to end up with a single image on a single piece of film. The reason why this worked so well was because the white sky—which looked essentially clear on the film—allowed the lightning image to be seen through the transparent portion.

When I recreated this same image in Photoshop, I obviously had to find a different method of combing the two images. It is almost impossible to cut around hair (with very few exceptions as I explained in Chapter One) and make the composite believable. To get the same result in the digital realm, I used a Blend mode.

I opened both the horse photo and the lightning photo. Working on the horse, I went to the Menu bar to use Select > All followed by Edit > Copy. This placed the horse photo in the clipboard, and then I clicked on the lighting image and pasted the horse image over it with Edit > Paste.

Then, in the Layers panel, I chose the Darken blend mode to darken the white, overcast sky, meaning that command made the light sky disappear. The result showed the lightning where the white sky had been. The horse and its mane with all of that flying hair remained unchanged.

High-Contrast Graphics

You can use the techniques already explained to create poster-like graphic images. The original photograph can be taken in soft and diffused light—or any other kind of natural or artificial light—and you can end up with a dramatic high-contrast result.

For example, I originally photographed the mountain lion, **9.15**, with film. The transparency was scanned and then I used the Magic Wand tool to select the sky. I then chose Select > Inverse to select everything *except* the sky, which left the cat and the rocks. I used Edit > Fill and selected Black from the Contents drop-down to make the subjects black.

To return to the background selection, I used Select > Inverse and then I opened Edit > Fill again from the Menu bar. This time, instead of filling the selected area with black, I chose Color from the Contents drop-down in the dialog (**figure D**). This opened a color picker, and I selected red.

Finally, I used the Elliptical Marquee (which is found beneath the Rectangular Marquee tool in the Tools panel) to proscribe a circle in the sky. I then went back to Edit > Fill to fill the circle with a bright shade of yellow, ending up with **9.16**.

9.15

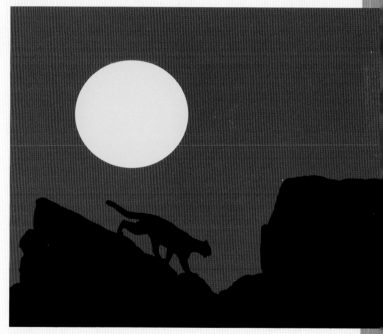

9.16

figure D

SMOKE

One of the intriguing components I work with in creating images is smoke. At first, you may not think it has much potential, but when I show you how to combine it with other elements, you'll wonder why you haven't discovered this long before now.

Photographing Smoke

In order to capture defined plumes of smoke with beautiful shapes, buy a package of incense. Any scent will do. If you don't have a local resource that sells incense, you can easily find it online as I did. It's inexpensive—just three or four dollars per package of a dozen or so sticks.

The setup is simple. I put the incense stick in a bottle or narrow vase with the combustible portion sticking out, and I place it in front of a black background. Black velvet is the best material to use because this kind of fabric absorbs light very well. The texture of the fabric won't show in the picture, and the background stays a rich black as opposed to looking dark gray as many black fabrics do.

To illuminate the smoke, I use flash. This is necessary because the brief burst of light freezes the movement and it enables you to use a lens aperture of f/32, which is what I recommend. The smoke has depth, and it's important to render it as sharp as possible. I place the flash off-camera at roughly a 90° angle to sidelight the smoke. You should avoid using on-camera flash for this because the smoke won't have a good sense of dimension.

The smoke photo I used for the final composite in this chapter is 10.1. Notice the edge lighting and how the plume of smoke is well distinguished from the background. That resulted from using off-camera flash at the 90° angle I mentioned.

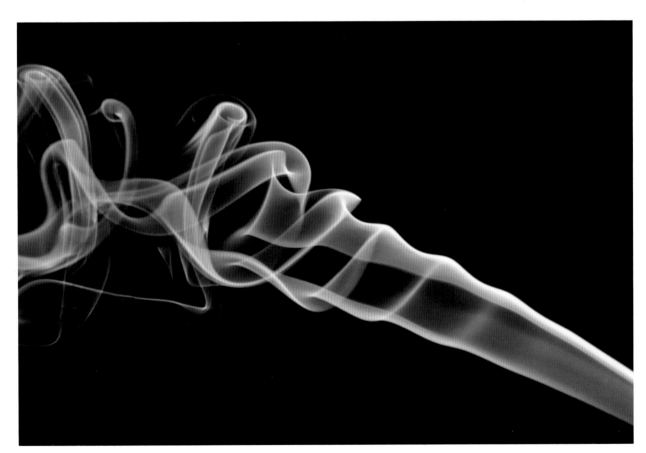

10.1

To trigger the off-camera flash,
there are four options:

1 Shoot in a room with very dim lighting and have a friend push the test button on the flash to fire it when he or she hears your shutter open. An exposure of ½ second gives your friend plenty of time to react and fire the flash, and the f/32 lens aperture, plus an ISO of 100 or 200, will prevent ambient light from contaminating the picture. This method doesn't incur any additional cost.

2 Use a connecting cable from the camera to the flash. Since you'll be shooting at close range—about 2 or 3 feet away—the cable doesn't have to be very long.

3 You can use a wireless trigger that works on an infrared line-of-sight mechanism, such as the Canon ST-E2, **figure A**. Other manufacturers make infrared transmitters too—Nikon makes them to work with their own camera and flash systems, plus there are a number of third-party manufacturers.

figure A

4 Use the Pocket Wizard, **figure B**, which works on a radio frequency. There are two small units, one that sits atop the camera in the hotshoe, and the other that attaches to the flash. The radio signal means that the flash doesn't have to be in the line of sight with the transmitter, so you can place the flash behind something and it will still fire.

The incense billows when you light it and continuously forms interesting and complex designs. I tried lighting two and three sticks at the same time, thinking that more smoke will produce better designs, but this turned out to be a mistake. All that smoke created too much visual confusion, and the nicely-defined shape of each plume blended with the other plumes—it turned out to be a mess. All of the smoke pictures that turned out well were taken from a single stick of incense.

figure B

The Composite

I wanted to put something inside the spiral of smoke, and as I was looking through my photo library I came up with the idea of putting a nude in there. The image I chose to work with was **10.2**. I specifically photographed this model against a white background because that made her easy to separate using Photoshop's selection tools, but there was another reason. Using a blending mode, a white background can completely disappear when it is combined with another image. That saves a lot of time, and the result is a flawless melding of two images together.

Before I placed the model inside the smoke, I wanted to infuse the smoke image with color. To do that, I made a duplicate layer (Ctrl/Command + J; PC/Mac), and then I chose the Gradient tool from the Tools panel. When this tool is activated, the Gradient box is visible in the Options bar above the workspace (**figure C**). When you click the drop-down arrow to expand this box, you'll

see a number of color palettes. I chose the rainbow option in the bottom left-hand corner, but any of these color palettes will produce amazing images.

To turn the white smoke into a multi-color abstract, run the cursor through the duplicate layer of the smoke and note that the color palette replaces the smoke completely, **10.3**. There is no need to be concerned, though, because now you can go to the blending mode drop-down in the Layers panel and choose Multiply. Instantly, the smoke takes on the color of the gradient while the black background remains black (**10.4**). The next step was to flatten the layers with Layer > Flatten Image in the Menu bar.

I then activated the photo of the model and used the Magic Wand tool to click on the background. This selected the white area. I then used Select > Inverse to grab everything except the background, which left the model selected. Using the Lasso tool, I subtracted

10.2

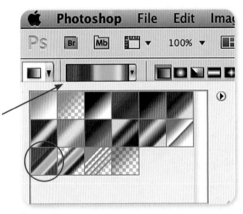

figure C

10.3

10.4

from the selection (by holding down the Option or Alt key) the subtle shadows beneath the model. The hair wasn't perfectly selected, but I knew this could be addressed later.

I copied the selection to the clipboard, Edit > Copy, and then pasted it into the smoke image. I opened Edit > Free Transform (Ctrl/Command + T) and sized the model appropriately, holding down the Shift key to maintain the image's proportions, then rotated her body by placing the cursor outside box and simply turning it. The screen capture, **figure D**, shows what this looked like. You can see the white paper background around the hair.

After scaling and rotating, I used the Move tool to position the model's body where I wanted it. To make her look like she was inside the smoke plume, I chose the Screen blending mode. This made the smoke appear to be wrapping itself around the model.

Finally, I flattened the layers with Layer > Flatten Image, and then used the Clone tool to eliminate the distracting white remnants around the hair from the original white background. The result is **10.5**.

figure D

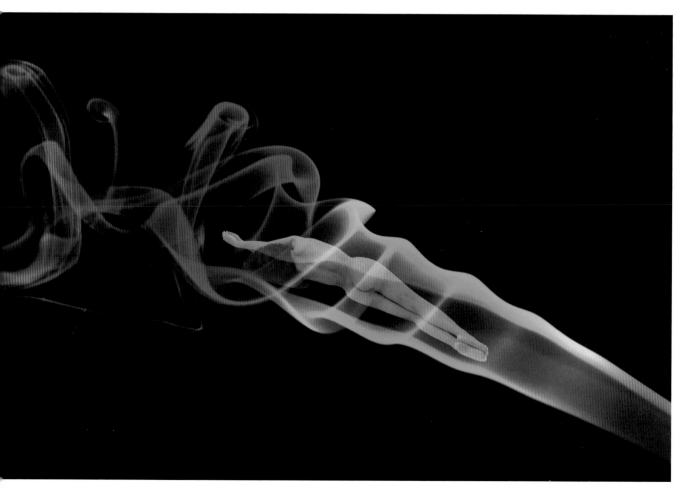

10.5

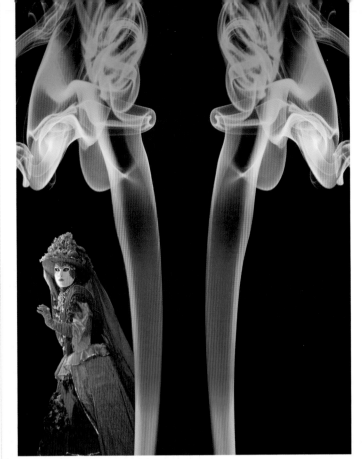

Variations

Once you have several interesting pictures of smoke in your library, you can combine them with other elements in many ways. For example, in **10.6**, I mirrored the smoke by pasting it into a black background twice and using Edit > Transform > Flip horizontal for one of the images. Then I cut and pasted a costumed model from Venice, Italy that I photographed during Carnival. To make it appear that the model was partially behind one of the plumes of smoke, I used the Magic Wand tool to select part of the black background and then, when the selected model had been copied to the clipboard, I used Edit > Paste Special > Paste Into. I placed her exactly where I wanted with the Move tool, and then sized her to fit using Edit > Transform > Scale.

In **10.7**, I did something very different—I applied one of my favorite Photoshop plug-ins, Flexify 2 (made by flamingpear.com, the same company that makes Flood) to abstract the smoke. I then obtained a high-resolution file of the Earth from NASA's website (it's in the public domain, meaning it's free), and pasted it into the center of the abstraction.

10.6

10.7

The composite photograph, **10.8**, is a combination of smoke turned into a mirror image with a rainbow. To make the mirror, I started by making the image canvas bigger using Image > Canvas Size. In **figure E**, you can see the tic-tac-toe graphic, where the grayed-out center represents your photo. If you change the numbers in the width and height boxes (make them bigger), new area will be added all around the photo. On the other hand, if you change only the width value and then click on the right center box in the grid below the width and height fields, then the new area will be on the left side of the photo. More about this in Chapter Thirteen.

That's is how I doubled the canvas size to accommodate a mirror image. I then cut and pasted the smoke into the new area. After I selected Edit > Transform > Flip Horizontal from the Menu bar, I used both the Move tool and the arrow keys (to nudge the layer into perfect position) until the smoke was mirrored. I used the Overlay blend mode to combine the smoke with the rainbow background.

I used the same mirror technique in creating the smoke environment for **10.9**. In this case, though, I mirrored the smoke first to the left and then downward so there are four panels. I combined a Javanese doll in the right side of the image because it seemed to me that the exotic nature of the doll fit the wild background.

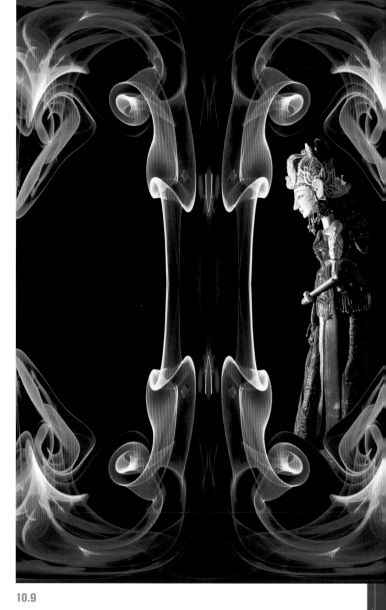

10.9

10.8

figure E

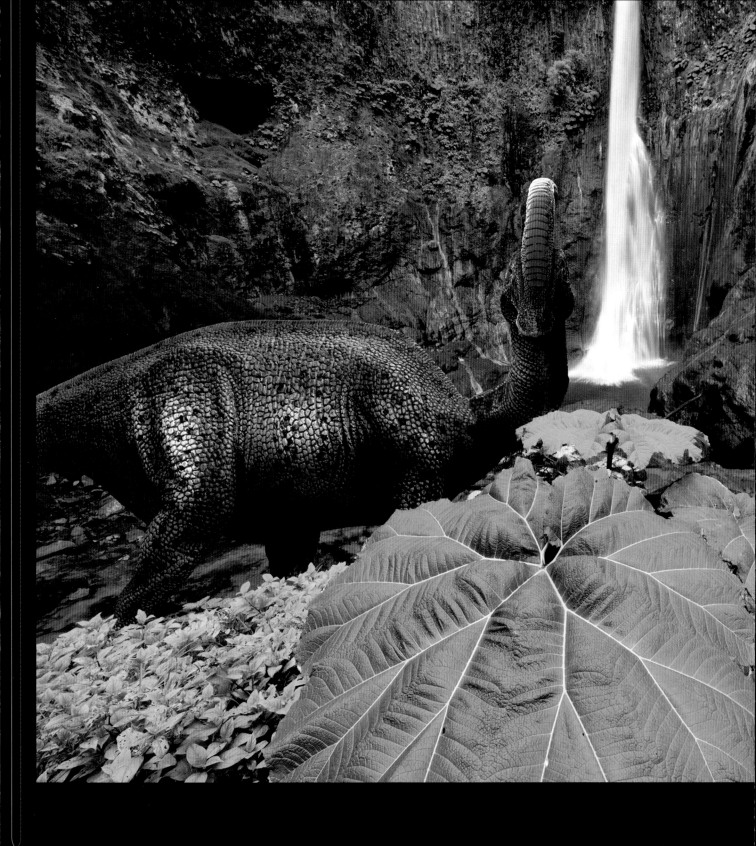

THE DINOSAUR

s a wildlife photographer, I find it eternally frustrating that I will never be able to photograph dinosaurs. I do love shooting large reptiles, but they just aren't dinosaurs. As an alternative, one of the first things I taught myself, when I first got Photoshop in 1991, was how to put dinosaurs into landscape photos. It was exciting then, and I still love doing it.

When I was doing this years ago, hobby stores were the best resource to find models of dinosaurs. They were sold in model kits that required assembly. Now, there are online sources that sell quite realistic, detailed models with reptilian-looking skin. Before I knew Photoshop well, I thought I was constrained to using the body positions that the model makers created, but now I know that's not true.

For example, the Parasaurolophus pictured in the Oneonta Gorge east of Portland, Oregon, 11.1, is exactly as I bought it. The animal's head is facing forward. In 11.2, I used the same model in front of the Catarata del Toro waterfall in Costa Rica, but this time the dinosaur's head is facing toward the camera, positioned at a 90° angle to its body. I thought that if a photographer could

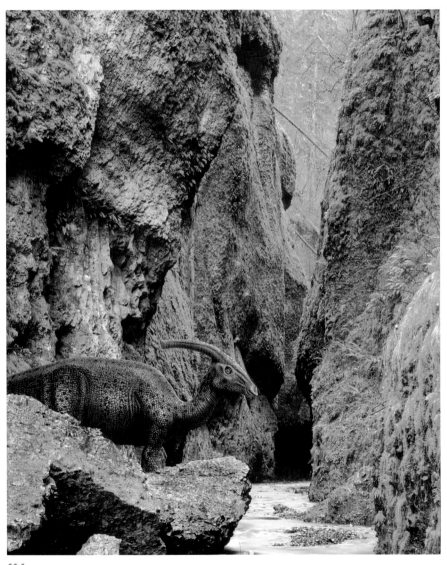

11.1

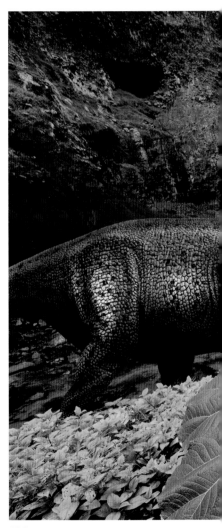

11.2

ever get this close to a dinosaur, the animal would probably be watching him closely, not munching on leaves, oblivious to the photographer's presence. Therefore, I wanted to be able to rotate the head of the Parasaurolophus.

The Photography

In order to turn the head of the dinosaur in Photoshop (remember that Photoshop is a two-dimensional program and we don't have the ability to move objects along three axes as we can in a 3D program), I took three pictures of the model, as illustrated in **11.3**, **11.4**, and **11.5**: One was a profile shot, one was an image where I positioned the model at approximately a 45° angle to the lens axis,

and finally, I took a picture where the dinosaur was facing the lens. I used a solid color—black in this case—as the backdrop to make selecting the dinosaurs easy.

Dinosaur models come in various sizes, and this one, although nicely detailed, is only 4½ inches (11.4 cm) high and 12 inches (30.5 cm) from nose to tail. This is not a child's toy; rather it is a detailed model I bought from DinoStoreus (www.dinostoreus.com). It was important to shoot it from as low a perspective as possible to suggest it was taller than the photographer. After all, the extinct Parasaurolophus was 40 feet long and 9 feet high at the hip, and it weighed about 4000 pounds! I used a 50mm lens and, with the model on the edge of a table, I shot with the camera lens at the

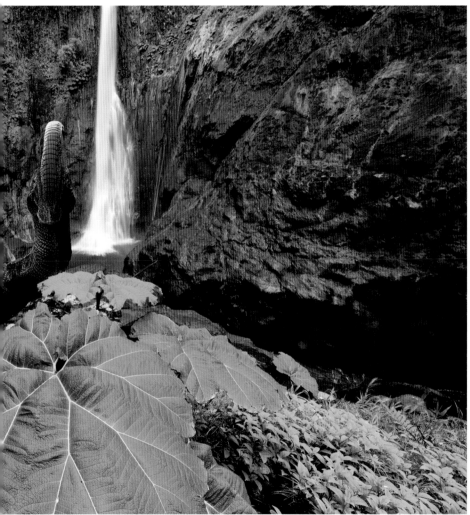

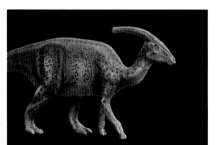

11.3

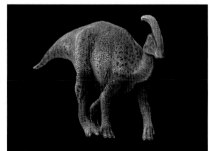

11.4

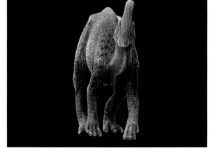

11.5

level of the tabletop. I used a tripod and a lens aperture of f/32 to make sure the entire animal was tack sharp. The last thing I wanted was to have shallow depth of field, because that would suggest macro photography, and with a 40-foot dinosaur, this would be anything but a macro shot! An ISO of 100 guaranteed the best possible quality.

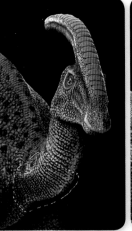
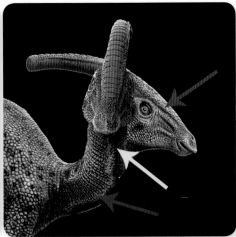

figure A figure B

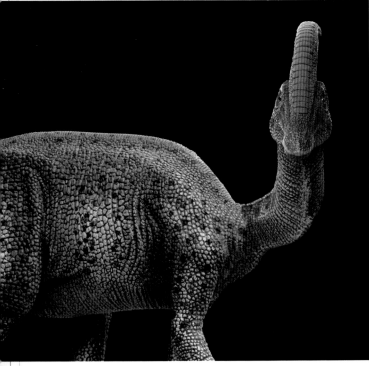

11.6

Turning the Head

I used the profile shot, 11.3, as my base image. But first, I opened 11.4 and chose the Lasso tool to select the portion of the neck shown in **figure A**. I then feathered the selection one pixel with Select > Modify > Feather. I copied this to the clipboard with Edit > Copy from the Menu bar, opened my base image, and then pasted the neck portion onto it using Edit > Paste. With the Move tool, I placed this section of the neck appropriately, and then I repeated the process by selecting the head of the Parasaurolophus in 11.5 and pasting it so that it connected with the neck to look correct. If there is a size discrepancy between the two shots of the dinosaurs, you will need to resize the head / neck layer using Edit > Transform > Scale.

Figure B shows the head and neck of the dinosaur before I did all the finishing work. The red arrow indicates the 45° angled neck section, the yellow arrow points to the new head looking at the camera, and the magenta arrow shows the profile head that will have to be cloned away. Because the profile head was on a different layer than the head looking directly at the camera, it was very easy to simply eliminate it. You could do it with the Brush tool and brush the color black over it, or you could do it with the Clone tool. To make sure the Clone tool works when you are dealing with layers, find the Aligned Sample drop-down in the Options bar at the top of the workspace and choose All Layers.

To blend the neck, I had to use the Clone tool. This took some finesse. I went back and forth between 100% and 50% Opacity to make the sections appear as seamless as possible.

In addition, you can see there is a subtle color discrepancy between the center section of the neck and the upper part of the neck that was attached to the head. This happened because the shading was different when I photographed the dinosaur, depending on how the light was striking the model as I rotated it, and because I might have adjusted the contrast and temperature sliders a little differently when I processed the RAW file. This issue was addressed using Image > Adjustments > Color Balance as well as Image > Adjustments > Hue / Saturation. I applied the color changes to each layer separately until they matched.

The final result can be seen in **11.6**. This was now ready to be pasted into the landscape. To do this, I used the Magic Wand tool to select the background. So that the Magic Wand tool didn't also

select shadow areas on the dinosaur in addition to the background, I set Tolerance to a very low number, like 1 or 2. (Find the Tolerance setting in the box located in the Options bar while the Magic Wand tool is selected). Once I had the background selected, I chose Select > Inverse from the Menu bar to grab everything except the background, i.e., the dinosaur.

figure C

The Composite

Every background photograph has its own challenges, and the strategy required to achieve a certain goal may vary from picture to picture. In this particular waterfall shot (see detail, **figure C**), the green foliage offered such a nice contrast against the brown rocky background that I didn't have to use the Pen tool to laboriously separate the plants from the rocks in order to paste the dinosaur in between them. Instead, I used the Quick Selection tool. This is located beneath the Magic Wand, and it's a miraculous way to separate elements in a scene.

I slowly dragged the tool along the edge of the big green leaves, and this gave me a perfect selection along that demarcation line. To grab the rest of the greenery, I had a choice. I could use the Lasso or the Quick Selection tool. Either one would work just as easily. I chose the Lasso because it was a little quicker. In order to add the Lasso selection to the Quick Selection tool's selection, hold down the Shift key as you use the Lasso tool.

Once the foreground plants were selected, I used Select > Inverse to select the rocks and not the plants. At this point, I highlighted the dinosaur image and selected the model, copied it to the clipboard, and then clicked on the waterfall shot and chose Edit > Paste Special > Paste Into from the Menu bar. This placed the dinosaur behind the vegetation. I clicked on the Move tool to move the reptile in place, and then with Edit > Transform > Scale, I sized it appropriately.

Shadows

The last thing I did was address the all-important issue of lighting. Even on an overcast day, everything casts a shadow. When animals are photographed in soft light, the sky is like a giant softbox providing overhead lighting, and therefore their underside will be darker than their back. Therefore, I used the Burn tool on 60% Opacity to slowly darken the lower legs, the belly, the neck, and the area below the tail. This added to the sense of realism because it added dimension and depth to the dinosaur.

Many Photoshop users make a duplicate layer when they burn and dodge, and that's not a bad idea because you can easily trash the layer and start over if you've made a mess. With a duplicate layer, you can also blend the burn or dodge effect with the background layer by using the Opacity option in the Layers panel.

Variation on a Theme

A similar technique can be used on a subject to change the angle or the shape of part of the body. For example, another dinosaur model, an Amargasaurus, 11.7, is positioned with its head up. I wanted to make it look like the reptile was bending its neck to drink in a lake. In order to do that, I had to cut and rotate one or more sections of the animal's body.

See figure D. I used the Rectangular Marquee tool to select a section of the head and neck, and then I used Edit > Transform > Scale. This put a box around the selection with small handles on it. If you place the cursor outside the box, near one of the corners, it changes into a tool with double arrows, and now you can rotate the entire box along with the portion of the animal that was selected. This leaves a gap, of course, between the left and right sides of the animal, but that will be rectified in a minute. Hit the Enter/Return key to apply the change.

I then selected several other sections of the head and neck and repeated this process. When I was done, the image looked like figure E. The point of doing this was to rotate the entire head and neck so it bends around toward the water.

To fill in the blank areas, I used the Clone tool at 100% Opacity. This was quick and easy, and when the dinosaur was completed, the angle of the head and neck was changed completely, figure F.

Next, I selected the model like I normally do using the Magic Wand and clicking in the white background, and then I using Select > Inverse to highlight and grab only the dinosaur. Because I wanted the Amargasaurus to be standing in water, I held down the Alt/Option key and used the Rectangular Marquee to subtract the feet from the selection. Notice the bottom of the selection in figure G, has a straight edge, which I did so the animal's feet looked like they were submerged in the water.

I feathered the edge of the selection with the usual one pixel, using Select > Modify > Feather, and then I pasted (Edit > Paste) it into a sunrise shot I had of Reflection Pond at the base of Mt. Rainier.

To make the reflection, I used the Photoshop plug-in Flood (made by flamingpear.com). Finally, I darkened the dinosaur to make it look right with the strong backlighting, 11.8.

11.7

figure D

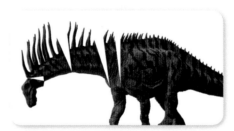

figure E

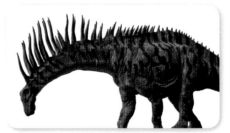

figure F

figure G

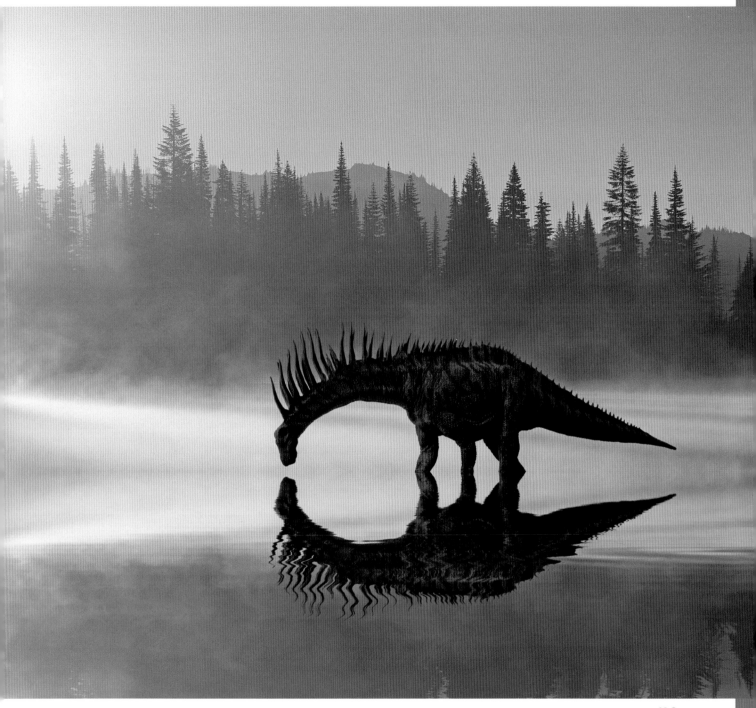

11.8

GRADIENT LAYER MASK

One of the most powerful tools in Photoshop is the Layer Mask, and when combined with the Gradient tool, it can solve some serious photographic challenges. For example, the picture of the giraffe drinking at a waterhole, **12.1**, is one I had wanted to take for a long time. I fortunately saw the animal approaching a small body of water across from the lodge in which I was staying, and I ran to a spot across the water where I would be dead center. When the giraffe spread its legs to lower that long neck, I had a symmetrical picture.

I was thrilled with the shot I got, but I wasn't thrilled with the background. The out-of-focus acacia tree was distracting to the composition. If I cloned it out, which was easy to do, I would be left with another problem—a bland, featureless sky, which was boring and unattractive, in my opinion. I could live with it, but I didn't like it. I didn't want to change the color of the sky to blue because that wouldn't make sense with the light on the animal. Instead, I wanted to introduce clouds that gave the sky some interest.

The problem, though, is the vegetation on both sides of the image. Melding vegetation with a new sky so it looks real is difficult, and when the vegetation is out of focus it's especially challenging. The best way to deal with this was to use a Layer Mask.

The Technique

With the giraffe photo open, I first used the Clone tool to eliminate the tree, working at 100% to make sure my work was precise along the edge of the giraffe's body. Next, I made a duplicate layer using the shortcut keys, Ctrl/Command + J (PC/Mac). The appearance of the image didn't change, but in the Layers panel, **figure A**, you can see that another layer was added.

Next, I opened a photo of storm clouds, in this case my choice was a horizontal image, **12.2**, although a vertical picture would have been fine, too. I chose a sky with a heavy cloud cover because the light would be soft—just like the light on the giraffe. I selected the entire image with Select > All and then used Edit > Copy to put it in the clipboard.

12.1 figure A

I clicked on the giraffe photo and hit Edit > Paste. With the Move tool, I moved the cloud photo up until its top edge coincided with the top of the giraffe shot, **figure B**. I made sure that the landscape portion of the cloud picture stayed low enough in the composition so it wouldn't show in the sky because it would be erased.

I then made a Layer Mask. This simply means that a mask is put in place that blocks certain parts of an image from being seen while it allows other parts to show. You can do this in one of two ways: Using the Menu bar, Layer > Layer Mask > Reveal All; or you can do what I do, which is to click on the icon at the bottom of the Layers panel that I've circled, **figure C**. This is the shortcut. The arrow points to the solid white icon that indicates the Layer Mask was created, although at the moment, nothing is masked.

figure C

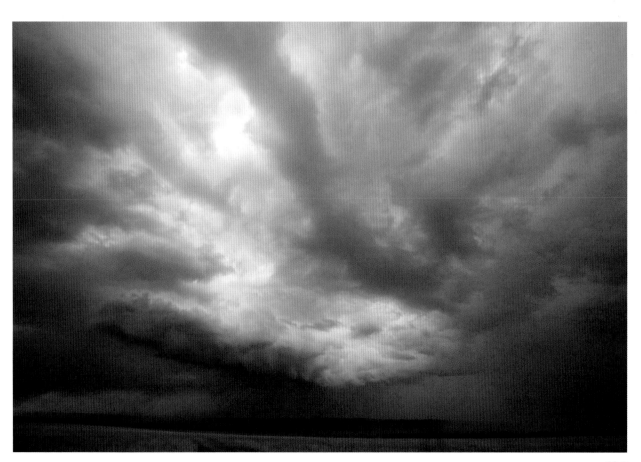

figure B

12.2

I now clicked on the Gradient tool. I made sure that the rectangular gradient icon in the Options bar was selected, as I've indicated by the circle in **figure D**. These small icons appear when you click the Gradient tool.

In the Foreground and Background Color boxes at the bottom of the Tools panel, I made the Foreground box black and the Background box white. This is essential.

Now everything is set to create the mask. The goal is to remove the clouds from the giraffe and from the trees so that the tops of these

elements blend in a natural way with the clouds that have replaced the original sky. To do this, with the cloud layer highlighted, I dragged the cursor from the bottom of the cloud photo about three or four inches upward. Immediately, a gradient is created in the clouds so that the bottom of the cloud landscape disappears, and what's left is the top portion. If the line that the cursor proscribes is too long or too short, it won't be usable as you can see in **12.4**. It may take you several tries to make the blend so it's perfect. Be patient. You don't have to undo what you've done—just do it again until it's right.

The problem that has to be addressed, though, is that the top of the giraffe sticks up into the sky. That means that some of the clouds are going to be superimposed over that part of the giraffe and possibly the tops of the trees as well. To eliminate the unwanted clouds, click on the Brush tool and use about 60% Opacity. Carefully brush away the clouds, being careful not eliminate the clouds in the sky. If you go too far and some of the clouds are removed from the part of the sky that touches the giraffe or the trees, reverse the Foreground and Background Color boxes so they show white and black, respectively, and then you can brush the clouds back in.

Adjusting the Opacity of the brush as you work will give you the kind of control required to make the image as perfect as possible. The final result is **12.5**. Notice in the Layers panel, **figure E**, that the Layer Mask icon that I've circled now shows the shape of the mask. The mask prevents the clouds from covering the giraffe and the lower part of the image while the top of the mask is clear, revealing the new clouds.

figure D

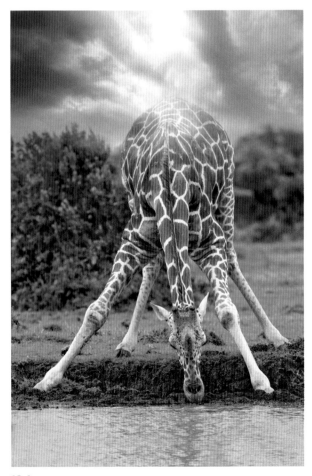

12.4

figure E

12.5

Three other sets of pictures present the same kind of problem, so I dealt with them using this same technique. The ruins at Moydrum in Ireland made a great subject, but the image was disappointing with that white sky (**12.6**). You can see the huge difference in **12.7**. The same is true of the elephant skull I photographed in Kenya, **12.8**. The white sky spoils the shot, and using any technique in Photoshop other than a Layer Mask would not make a new sky believable. As you can see in **12.9**, the blend of the clouds with the palm fronds is perfect.

The group of giraffes I found in Namibia, **12.10**, isn't a terrible shot, but the background was disappointing because it was too washed out when I first shot the photo using film. Never underestimate the power of a background—and especially a sky—to significantly impact a photograph. When I replaced the sky (**12.11**), the difference was remarkable. The African landscape was transformed from ho-hum to dramatic. What is noteworthy about this technique is that it circumvents the necessity of meticulously cutting around small details like leaves and grasses, which would be impossible to do in most cases to produce a believable-looking composite.

12.8

12.6

12.7

12.9

12.10

12.11

13

MIRRORS

O ne of my favorite techniques is to mirror an image to create something that couldn't possibly exist. It is a unique approach to making images, producing an otherworldly blend of surrealism and fine art. You can use this technique for any subject—nature and architecture are particularly exciting—but it is the human face and body that I find especially intriguing.

For example, I took the original portrait of a model, **13.1**, in a studio with two softboxes and a neutral background. She was wrapped in a colorful Indian sari. Notice that her right eye (our left) is slightly larger and more round, so when I used the mirror technique, this was the side of the face I duplicated.

To turn this photo into a mirrored portrait, I chose the Rectangular Marquee tool and made a vertical selection from the top of the image to the bottom, dividing the nose in half, choosing the left side (my left) of the photograph. If the selection is close to what you want but not perfect, you can move it pixel by pixel by using the arrow keys. When the Marquee tool is selected, the arrow keys nudge the selection up or down and to either side. **Figure A** shows the selection I made.

I copied this to the clipboard (Edit > Copy), and then I chose Select > Inverse from the Menu bar. Now the right side of the photo was selected. From the Menu bar again, I then went to Edit > Paste Special > Paste Into. The clipboard image was placed inside the selection at this point. To make the mirror, it had to be flipped horizontally. I used the command Edit > Transform > Flip Horizontal.

The two halves didn't connect with precision, so using the arrow keys I nudged the layer into place. At 100% magnification, I could see that I had a perfect match, **13.2**. I now flattened the layer with Layer > Flatten Image.

The next thing I did was use the Healing Brush to remove the sheen on the model's nose. It's very difficult to use the Clone tool on skin because there are so many shades of color, and the healing brush blends tones in such a way that it makes retouching much easier.

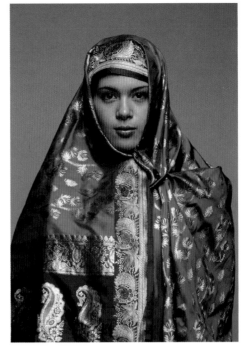

13.1

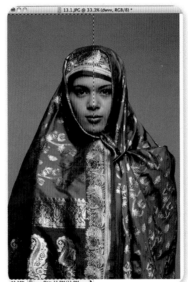

figure A

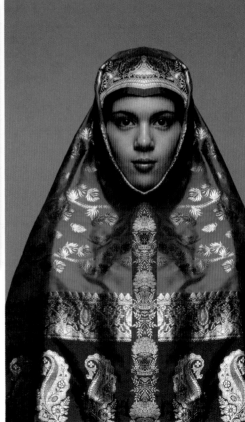

13.2

figure B

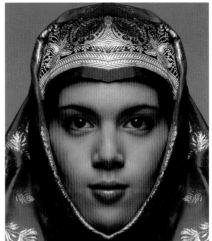

13.3

Then, I wanted to narrow the tip of the model's nose. To do this, I chose the Rectangular Marquee tool and put a box around the nose that included some of the face as well. I did this because the Liquify tool is fairly slow, and by selecting only part of the image I'm working on, this speeds up the computer's computations of the changes I make. I now opened Filter > Liquify. This gave me access to a new workspace (**figure B**). With the Forward Warp tool selected (white arrow), I adjusted the size of the brush with the Brush slider (circled), and then I simply pushed the nose into the shape I wanted. I hit OK, and then used the Healing Brush again to remove a couple of shadows at the side of the nose (**13.3**).

To produce more drama and visual impact, I wanted to add a glow to the model, and I also felt that the background needed to be a lot more exciting. First, I selected the background with the Magic Wand tool and then expanded the selection by one pixel (Select > Modify > Expand) to make sure I captured even the transition zone—those pixels that included the colors and tones of both the model and the gray backdrop. To soften the edge slightly so it didn't have such a sharp and unnatural demarcation line, I next used Select > Modify > Feather. I also chose one pixel and then hit OK.

I clicked on the Gradient tool, and I chose one of the dynamic blends of colors in the Options bar (**figure C**). I dragged the cursor down through the photo, and the colors I had selected replaced the boring gray background.

figure C

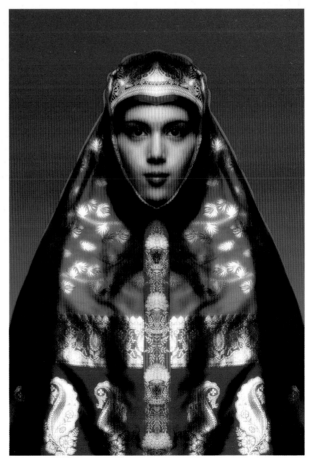

13.4

Color Efex Pro 4

To add the diffusion glow you see in 13.4 (page 121), I applied Glamour Glow, one of my favorite plug-ins from Nik Software in their suite of filters, Color Efex Pro 4.

It infuses an image with an ethereal, artistic quality that I find beautiful and dramatic at the same time.

In figure D, you can see the image I started with on the left. I enhanced the photo on the right by selecting the Glamour Glow preset (circled). The black arrow points to the dialog box that allows further tweaking. You can adjust the amount of the glow, the saturation of the colors, and the color temperature (by making the image more yellow or more blue).

The white arrows point to Control Points that allow you to subtract the effect for any area of the image you want. I clicked on the Control Point icon in the panel, and then I clicked on one of the eyes. By adjusting the two horizontal sliders that appear, I chose the "area of influence," as well as the Opacity of the filter effect. I did this to reduce some (but not all) of the filter effect on the eyes so they were fairly sharp. I then repeated this on the other eye.

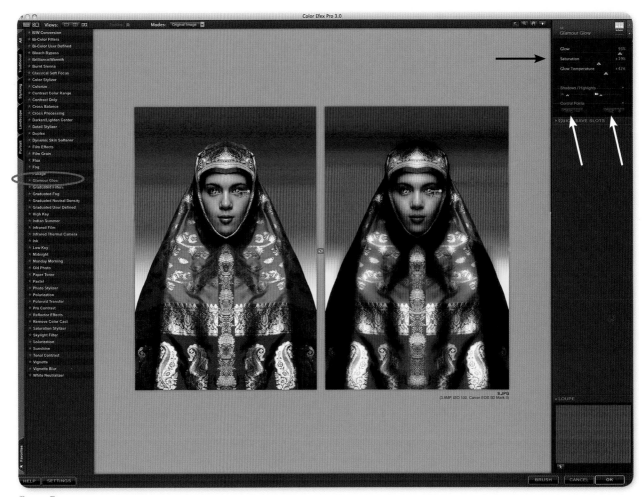

figure D

Variations

There are so many creative possibilities with the mirror technique, and I certainly don't want to give the impression that it should be limited to faces. One of my favorite approaches is to mirror a background and then insert a single image into the scene so the subject isn't mirrored. Architecture and cityscapes work great for this, and so do landscapes.

For example, I mirrored a scene from Venice, 13.5, by first using Select > All and then Edit > Copy, and then I chose Image > Canvas Size from the Menu bar. In the dialog box, figure E, the width was 23.4 inches. I doubled that number to 46.8 as you can see in figure F, and I clicked the right center box in the tic-tac-toe graphic. This means that the expanded area will be to the left, and figure G shows the result of doing that.

It was now a simple matter of using the Magic Wand tool to select the white portion of the image (the color comes from the Background Color box at the bottom of the Layers panel) and using Edit > Paste Special > Paste Into. Remember that the original scene was already in the clipboard, so I pasted it into the selection. Finally, I used Edit > Transform > Flip Horizontal to produce 13.6, and then flattened the image using Layer > Flatten Image.

I know that many photographers like panorama images, but personally I have no use for them. I don't hang long prints in my home, and it's very hard to get images like this published. Therefore, I wanted to change the panorama rectangle to the 2:3 ratio that comes out of most cameras. To do this, I used Image > Canvas Size again, this time adding more picture area above and below the photo. I left the gray center in the middle of the tic-tac-toe graphic and simply changed the height of the image. I ended up with figure H.

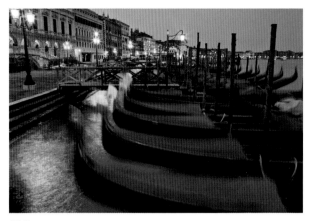

13.5

figure E figure F

figure G

figure H

13.6

I then selected the photo using the Rectangular Marquee tool and chose Edit > Transform > Scale. This put a box around the picture. I then grabbed the center top handle and pulled it all the way up to the top of the frame. Next I pulled the center bottom handle all the way to the bottom of the frame. This stretched the photo, and when I clicked OK, the image had the proportion I wanted.

In the original picture of the costumed model, **13.7**, I filled much of the frame with the woman. Therefore, I knew I would have to reduce her in size for her to fit into the new background. It's fine to reduce a subject in size, but enlarging on the other hand, can be problematic. If you enlarge it too much, there is a danger of losing too much quality.

To put the model behind the lamppost, I used the Lasso tool to select the post. Then I feathered the selection one pixel with Select > Modify > Feather. I then chose Select > Inverse so that everything except the post was selected. Now the image was ready to receive the model.

I selected the model using the Quick Selection tool, and then I copied her to the clipboard and used Edit > Paste Special > Paste Into to place her behind the lamppost. I then used Edit > Transform > Scale to reduce her in size and Edit > Transform > Flip Horizontal to turn her to face the other direction, and then I opened up Image > Adjustments > Color Balance to add some yellow to the model so she looked as if she were receiving some of the warm glow from the lamps. The last step was to put a subtle shadow at the base of the dress. I did this with the Burn tool on 30% Opacity. The final result is **13.8**.

13.7

13.8

Gallery

Photos **13.9** through **13.15** illustrate how different types of images look when mirrored. You can see how a wide variety of subjects work very well with this technique: a small Italian village, landscapes, flowers, a mask with a wild background, and a fashion model combined with lightning. This technique can be used over and over again with remarkable and unexpected results.

When you are looking for images to use with the mirror technique, start with pictures that have strong graphic forms. Diagonal lines always turn out great, too. Tree branches, a model posing with her arms or legs positioned in diagonals, angled architectural lines, shorelines, and so on make amazing designs when mirrored. The fun part of this technique is that you can't previsualize what the design will look like until you see it, and usually it's an artistic surprise.

13.9

13.10

13.11

13.12

13.13

13.14

13.15

cover
Bent
3/13

INDEX